ALFRED STIEGLITZ AT LAKE GEORGE

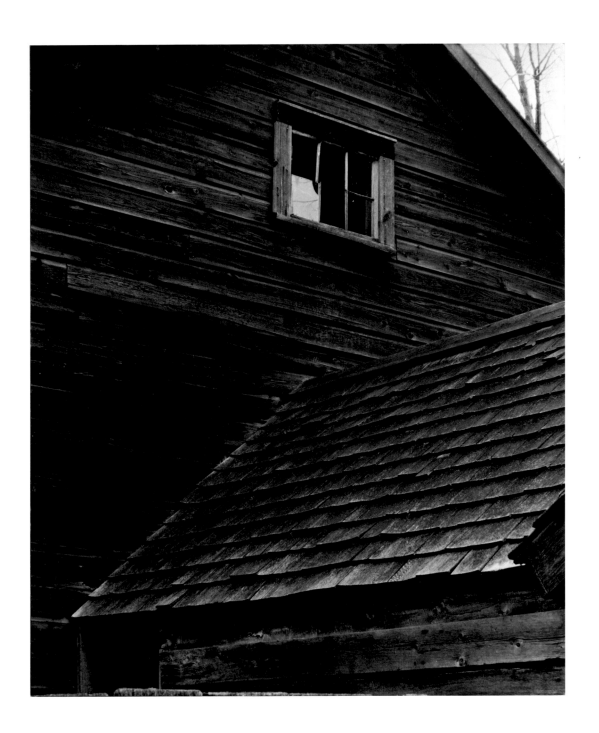

ALFRED STIEGLITZ
AT LAKE GEORGE

JOHN SZARKOWSKI

.

THE MUSEUM OF MODERN ART, NEW YORK

DISTRIBUTED BY HARRY N. ABRAMS, INC., NEW YORK

Published on the occasion of the exhibition
ALFRED STIEGLITZ AT LAKE GEORGE, organized by
John Szarkowski, Director Emeritus, Department of
Photography, The Museum of Modern Art, New York,
September 14, 1995–January 2, 1996.

Also shown at

Kunst- und Ausstellungshalle der Bundesrepublik
Deutschland, Bonn
February 9–April 14, 1996

San Francisco Museum of Modern Art
June 20–September 22, 1996

This exhibition and publication are made possible by a generous
grant from Springs Industries, Inc., and are part of The Springs of
Achievement Series on the Art of Photography.

Produced by the Department of Publications
The Museum of Modern Art, New York
Osa Brown, Director of Publications
Edited by Harriet Schoenholz Bee
Designed by Emily Waters
Production by Amanda W. Freymann
Composition by U. S. Lithograph, typographers, New York
Separations by Robert J. Hennessey
Printed by Litho Specialties, Inc., St. Paul
Bound by Midwest Editions, Inc., Minneapolis

Printed in the United States of America

Library of Congress Catalogue Card Number: 95-077546
ISBN: 0-87070-138-X (clothbound, MoMA, T&H)
ISBN: 0-87070-139-8 (paperbound, MoMA)
ISBN: 0-8109-6149-0 (clothbound, Abrams)

Published by The Museum of Modern Art
11 West 53 Street, New York, New York 10019

Clothbound edition distributed in the United States and Canada
by Harry N. Abrams, Inc., New York, A Times Mirror Company

Clothbound edition distributed outside the United States and
Canada by Thames & Hudson, Ltd., London

FRONT COVER: *Door to Kitchen*. 1934. Gelatin-silver print. 9 1/2 x
7 3/8" (24.1 x 18.8 cm). National Gallery of Art, Washington, D.C.
Alfred Stieglitz Collection

BACK COVER: *Richard*. 1931. Gelatin-silver print. 4 5/8 x 3 5/8"
(11.7 x 9.2 cm). National Gallery of Art, Washington, D.C.
Alfred Stieglitz Collection

FRONTISPIECE: *Lake George*. 1920. Gelatin-silver print. 9 1/2 x
7 5/8" (24.3 x 19.4 cm). The Museum of Modern Art, New York.
The Alfred Stieglitz Collection, gift of Georgia O'Keeffe

PAGE 8: *Lake George*. 1932. Gelatin-silver print. 4 1/2 x 3 5/8"
(11.5 x 9.3 cm). The Museum of Modern Art, New York.
The Alfred Stieglitz Collection, gift of Georgia O'Keeffe

CONTENTS

THE SPRINGS OF ACHIEVEMENT SERIES
ON THE ART OF PHOTOGRAPHY

Just as new art often teaches us to see older art from a fresh perspective, new understandings of the art of the past repeatedly enrich the art of the present. The Museum of Modern Art, long devoted to this vital dialogue, now invites us to see the art of Alfred Stieglitz in a new light. Stieglitz is one of the great masters of modern photography, but this exhibition and book are the first to explore fully an essential, and perhaps the richest, chapter in his work.

The Springs of Achievement Series on the Art of Photography was initiated in 1978 with two exhibitions at The Museum of Modern Art. Now nearing thirty in number, the Series is devoted to celebrating creative achievement, new and old, and to fostering the enjoyment and understanding of photography by a broad public. Springs Industries proudly extends the Series by supporting this original exhibition and the important book that accompanies it.

Walter Y. Elisha
Chairman and Chief Executive Officer
Springs Industries

FOREWORD

In the United States Alfred Stieglitz left a deep and indelible mark on both the substance and the perception of modern art. In the early decades of the century—with Alfred H. Barr, Jr., Albert C. Barnes, and a few others—he taught Americans how to think, and sometimes what to think, about the new art.

Our appreciation of Stieglitz's importance as a pedagogue and impresario has perhaps outstripped our consideration of his work as an artist—the role that he would surely have considered the central issue of his life. This book, and the exhibition it serves as a catalogue, shows—in a depth never before publicly seen—one aspect of Stieglitz's work, done during the climactic years of his life as a photographer.

The Museum of Modern Art is indebted to Georgia O'Keeffe, who made this exhibition possible by agreeing to John Szarkowski's 1983 request that she release the National Gallery of Art from the restrictions governing the loan of pictures from its definitive Stieglitz collection. This is the first time that Stieglitz has been exhibited in depth at the Museum since the posthumous 1947 retrospective directed by James Johnson Sweeney. Circumstances at the time prevented the publication of a catalogue, which makes it all the more satisfying that the Museum is able to preserve the current exhibition in this permanent form.

Springs Industries, Inc., has been a supporter of the Museum's photography program for almost twenty years. Among the major projects they have helped support have been *Ansel Adams and the West* (1977), the four-part exhibition *The Work of Atget* (1981–85), *Winogrand: Figments from the Real World* (1988), *Photography Until Now* (1990), and the continuing annual report on current work, the New Photography series. On behalf of the Museum and its audience I would like to thank Walter Y. Elisha and Springs Industries for their continuing service to the Museum and to the art of photography.

This exhibition and its catalogue would not have been possible, however, without the insightful work of John Szarkowski, Director Emeritus, who for twenty-nine years guided the Museum's Department of Photography.

Finally, we are grateful to the lenders to the exhibition—the National Gallery of Art, George Eastman House, The Art Institute of Chicago, The J. Paul Getty Museum, San Francisco Museum of Modern Art, and The Metropolitan Museum of Art—for sharing their collections with us.

Glenn D. Lowry
Director
The Museum of Modern Art

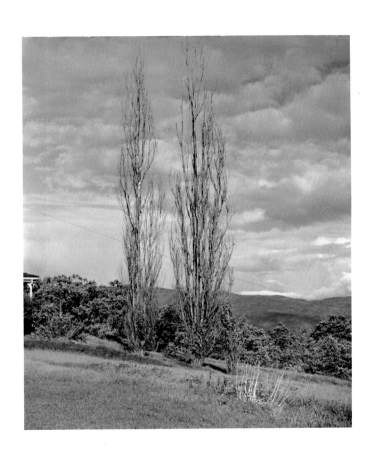

ALFRED STIEGLITZ AT LAKE GEORGE

A MILLION WORDS have been written about Alfred Stieglitz, but it has proven difficult to find the right ones. And the end of the difficulty is not in sight. We have been given hagiographies and exposés, memoirs, works of fastidious scholarship, and works grounded on faith, but in spite of the virtues of these various views we still seem to have not quite a full and satisfying portrait. Caricature—both graphic and literary—has perhaps worked better (fig. 1). Twenty years ago Mahonri Sharp Young produced a splendid quick sketch, short enough for an epitaph, that tells us as much as most of the thick books, and perhaps also suggests why even now we do not know the subject better. Stieglitz, he said, "was a hypnotist and American Gurdjieff, and those who remember him, believe in him still."[1]

But most of us do not remember him; there are few left who do. If the rest of us choose to believe in him, it will be not because of the force of his will or his pedagogical passion (which will be preserved more and more faintly, by hearsay) but because of his work as a photographer.

Stieglitz is famous, but his work is little known. No other major figure of photography's modern era is known by so short a list of pictures. Even among painters, who are reasonably assumed to be less prolific than photographers, perhaps only van Gogh is known to a broad art public for so few works, and his mature output was produced within five years. Stieglitz, whose life as a photographer spanned more than fifty years, has too often been anthologized from a standard list of half a dozen pictures, none of which was made during the last half of his working life. The reasons for this peculiar situation are for the most part traceable to policies instituted by Stieglitz's widow Georgia O'Keeffe, acting in what she felt were the best interests of his memory and his art, and in the spirit of the crankily elitist perspectives that characterized his thinking (or his feeling) during his last years.[2] These policies resulted in highly restricted access to Stieglitz's work, except for the small fragment that had been previously published, primarily in Stieglitz's own magazine *Camera Work* (1903–17). The history of these policies is interesting in itself, but only indirectly relevant to this study. What is directly relevant is the critical environment that resulted from a denial of access to his photographs. It has been an environment in which Stieglitz's words—and his words as recollected by others, often long after the fact—were more readily available than his pictures. One might say that they became more important than his pictures.

Stieglitz was of course more than a photographer; he was an editor, a publisher, a proselytizer, a perpetual protester, an art dealer, and a visionary. It is said that during the first decade of this century he introduced modern art to America, which is perhaps as true as so sweeping a statement should hope to be. After the famous Armory Show of 1913 had encouraged other evangelists to join him in praising (and sometimes selling) work by the great European pioneers, Stieglitz changed his ground, and between the two World Wars he was the devoted agent and protector of most of the best American painters of the time. In return he asked of these artists nothing but absolute unqualified trust, or at least the appearance of it.

Stieglitz was clearly "not just" a photographer; but his younger colleague and sometime

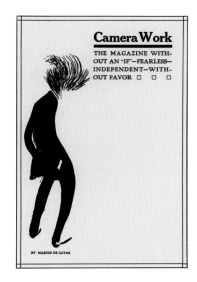

1. Marius De Zayas. Untitled (caricature of Stieglitz). Published in *Camera Work*, no. 30 (April 1910).

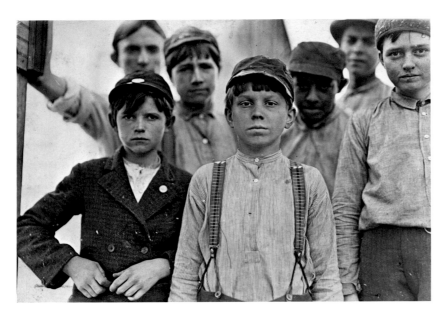

2. Lewis W. Hine. *Macon, Georgia*. 1909. The Museum of Modern Art, New York. Stephen R. Currier Memorial Fund.

great collaborator Edward Steichen (himself a man with more than one string in his bow) wrote near the end of his own life this:

Stieglitz's greatest legacy to the world is his photographs, and the greatest of these are the things he began doing toward the end of the 291 days.[3]

"291" was Stieglitz's first gallery, which opened its doors at that Fifth Avenue address in 1905, a little later than and a little north of Daniel Burnham's Flatiron Building. At first the place was called The Little Galleries of the Photo-Secession (the Photo-Secession being the group that Stieglitz had founded in 1902) but soon it was called simply "291," to indicate that its interests would not be limited to photography. The gallery closed in 1917, after holding eighty exhibitions, including one-person shows on many of the major figures of early twentieth-century art.

When "291" closed Stieglitz was fifty-three.

This book and the exhibition it accompanies consider Stieglitz's work during the next two decades at his summer home, six hours north of the city, at Lake George.

■

In 1910, at the age of forty-six, Alfred Stieglitz mounted an exhibition of six hundred photographs, ranging chronologically from the calotypes of David Octavius Hill and Robert Adamson—made in the 1840s during photography's first decade—to a substantial number of pictures (including eight of his own) that had been made in the very year 1910. The exhibition was an attempt to define the character and the achievement of the art of photography. It had been commissioned by the distinguished Albright Art Gallery of Buffalo, New York, and Stieglitz had been given absolute control over its content and installation. The show thus provided the opportunity for him to demonstrate in concrete terms the rightness of the positions that he had staked out and fought for during the previous twenty years.

During at least the last half of that period Stieglitz had been, in America, the leading arbiter of aesthetic and philosophic issues among the small world of photographers who claimed the status of fine artists; the Buffalo exhibition might therefore also be regarded as an accounting of his stewardship. Stieglitz took the challenge very seriously; his grand-niece Sue Davidson Lowe says that he expended a greater effort on this show than on any other of his long career.[4] Nevertheless, it is difficult to avoid the conclusion that the exhibition was a failure.

Within the small world of pictorialist photography the show was criticized for an ungenerous and parochial bias toward Stieglitz's own circle, the Photo-Secession, the group that he had decreed into existence in 1902 and over which he exercised virtually dictatorial control. The Photo-Pictorialists of America, a larger but

less sharply focused rival group, claimed to have been under-represented, and they were perhaps right in terms of the project's stated perspectives, but from our vantage point the argument seems a tempest in a teapot. In terms of quality, narrowly defined, the photographers of the Photo-Secession were on average probably better than those of the Photo-Pictorialists of America, but both groups were playing the same game, and it seems now a game of very limited horizons. Stieglitz's show included the work of many photographers whose names are now mysteries to all but the most specialized scholars, and who were presumably known then only within the trade union of high-art photography. On the other hand, it did not include (for example) the work of Carleton Watkins or Eadweard Muybridge, who were famous and who, like Stieglitz, had won many medals; nor, excepting Hill and Adamson, did it include work by any of the great nineteenth-century European photographers, which Stieglitz must surely have seen on his travels; nor a picture by Stieglitz's New York neighbor Lewis W. Hine (fig. 2); nor one by Peter Henry Emerson, whose work and thought Stieglitz had known for years; nor one by the great Frances Benjamin Johnston (fig. 3), who was an Associate Member of the Photo-Secession, but unfortunately a professional; nor was there (it would seem, from reading the titles in the catalogue) a photograph of an automobile. There was in 1910 little painterly precedent to suggest how a photographer of high-art ambitions might deal with automobiles.

The work omitted from the Buffalo show would surely seem to a modern viewer more original, radical, and challenging than the work included. It is fair to assume, I think, that it was omitted because it did not conform to Stieglitz's conception of art, and this fact now seems a clear indictment of that conception.

It is difficult to evaluate the written criticism of the Albright exhibition; it seems scant

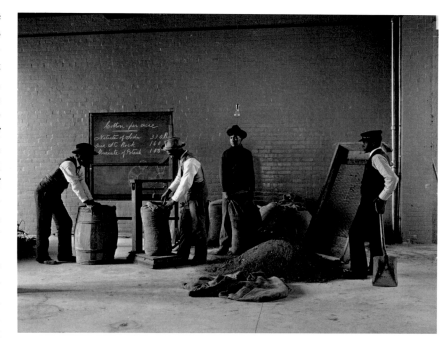

and parochial, and far from disinterested. Critics tied to the photographic enterprise were naturally impressed that six hundred photographs had been hung in a distinguished museum, and in the circumstances were perhaps disinclined to scrutinize the content of the show too closely. Even so, after explaining that the exhibition was, yes, wonderful, and thanking the Photo-Secession for its "historic achievement," one F. Austin Lidbury spoiled it all by suggesting that, "If one only gets a proper attitude of mind, all these rather weak-looking performances fall properly into place as Milestones in the Path of a Movement."[5] Lidbury ends his lengthy review in *American Photography* by stating his view that the exhibition was in several respects a last word, a signing off. He also thought (or perhaps hoped) that it was the last photographic exhibition of its "gargantuan" size.

Sadakichi Hartmann also wrote on the show; he had been closely associated with the Stieglitz

3. Frances Benjamin Johnston. *Agriculture: Mixing Fertilizer.* 1899–1900. From *The Hampton Album*. The Museum of Modern Art, New York. Gift of Lincoln Kirstein.

camp for more than a decade, and has been credited with having been a major influence on the evolution of Stieglitz's artistic thought.[6] His review of the Albright show was published in *Camera Work*—Stieglitz's own magazine. Nevertheless, after the obligatory compliments have been paid, Hartmann goes on to make it clear that, in his view, the achievements of pictorial photography have been quite limited, interesting and admirable, but limited: "One can hardly say that photographic picture-making up to this day has revealed much of spiritual gravity."[7]

Most of all we would want to know Stieglitz's opinion of the exhibition, but he seems to have said remarkably little about it. He told the German critic Ernst Juhl that the exhibition "was without a doubt the most important that has been held anywhere so far," but he seems to have been speaking primarily of the show's political significance: "The dream I had in *1885* in *Berlin* has been realized—*the full recognition of photography by an important art museum!*"[8] Steichen wrote from France the month after the show opened, and (at the end of his letter) said that he was anxious to hear news of the Buffalo show, but if Stieglitz replied, it did not elicit a further response from Steichen, who wrote again at least three times in the next two months without again raising the question.[9]

When an audience was available, Stieglitz spoke—on topics of his own choice—and although these generally focused on himself, he tended to exclude those episodes of the past that had not turned out to his satisfaction. It is interesting in this regard to consider *Alfred Stieglitz Talking* by Herbert J. Seligmann, perhaps Stieglitz's least critical Boswell.[10] On his many visits to The Intimate Gallery (Stieglitz's second gallery) during the late twenties, Seligmann seems to have written down everything he heard Stieglitz say; and his report never once mentions the Photo-Secession or any of its members, except for the longtime Associate Editor on *Camera Work*, Joseph Keiley (remembered in Seligmann's book as one who did not at first appreciate Stieglitz's most famous photograph *The Steerage*),[11] and Edward Steichen, who is remembered in these years as a veritable Judas.[12]

Stieglitz seems not to have told us what he thought of the Albright show, but we can try to make sense out of the facts we know. From the founding of the Photo-Secession in 1902 until 1910 Stieglitz had had little time for his own photography and perhaps not much interest in it. It is possible that the political battles were more compelling. In addition to competing with the other groups that claimed to speak for artistic photography, Stieglitz also had to be sure that the Photo-Secession itself was free of doctrinal error. (In 1903, in a general answer to inquiries concerning conditions for membership in the Photo-Secession, Stieglitz wrote in *Camera Work*: "It goes without saying that the applicant must be in thorough sympathy with our aims and principles.")[13]

The Buffalo show was a pure expression of those aims and principles, the realization of Stieglitz's dream, as he told Juhl. But once the battle was won it may slowly have begun to occur to Stieglitz that it had been the wrong battle, fought on the wrong field. Nine years later, in a letter to Paul Strand, he wrote of the earlier years: "There was too much thought of 'art,' too little of photography."[14]

■

In 1910 the art collector John Quinn, in a letter to the painter Augustus John, identified Alfred Stieglitz as a former photographer,[15] but in that year Stieglitz again took up his camera—presumably so he might properly represent himself in the great exhibition that he was forming—and made at least eight superior new pictures, which he included in the Buffalo show.[16] Stieglitz's choice of his own work for the exhibition reveals the remarkably spasmodic character of his

production. He chose twenty-nine pictures to represent a period of twenty-eight years—since he began his work as a photographer in 1883.[17] In addition to the eight made in the year of the exhibition, ten date from 1894, all of them made in Europe. The remaining twenty-six years are represented by eleven pictures. Prior to those produced by the spurt of activity in 1910, the most recent picture that Stieglitz considered worthy of the show had been made five years earlier.

The arrhythmic nature of Stieglitz's achievement as a photographer continued until about 1915. It is useful to study the chronological distribution of the works reproduced in *Alfred Stieglitz: Photographs and Writings* (1983),[18] selected from the collection of the National Gallery of Art—by far the most nearly complete holding of his work.[19] In the National Gallery's selection, only nine (out of seventy-three) plates represent the twenty years between 1895 and 1914—that is, between Stieglitz's thirtieth and fiftieth years, when one might expect an artist to be most prolific. The next twenty years, reaching almost to the end of Stieglitz's working life, are represented by fifty-two pictures.

The pictures of 1910 have a confident new breadth about them—a graphic sweep that distinguishes them from his typical earlier work— but in this Stieglitz is swimming with the tide of the time. In terms of mood, there is little in the new pictures that challenges the sentimental vagueness endemic to the high-art photography of the time. It is difficult to recall a more lavishly romantic vision of a modern metropolis than *The City of Ambition* (fig. 4)—New York seen beyond a ribbon of sparkling water, the back-lighting converting every puff of steam and smoke into a feather plume, and every counting house into a castle. Both in their romantic mood and in their more consciously constructed formal character, the new pictures look rather like those of the young Alvin Coburn—younger even than Steichen.

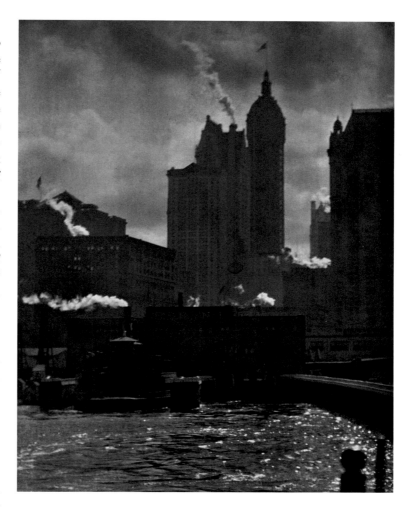

One of Stieglitz's most impressive qualities as an artist was his ability to learn from younger artists. Consciously or otherwise, he accepted, adopted, and adapted the successes of his juniors. In his thirties he learned from Steichen and Clarence White; in his forties he learned from Alvin Langdon Coburn; at fifty he learned his greatest lesson, from the first mature work of Paul Strand and perhaps that of Charles Sheeler. At an age when most artists are content to refine the discoveries of their youth, Stieglitz, who had been famous almost forever, had not yet begun his best work.

4. Alfred Stieglitz. *The City of Ambition*. 1910. The Museum of Modern Art, New York. Purchase.

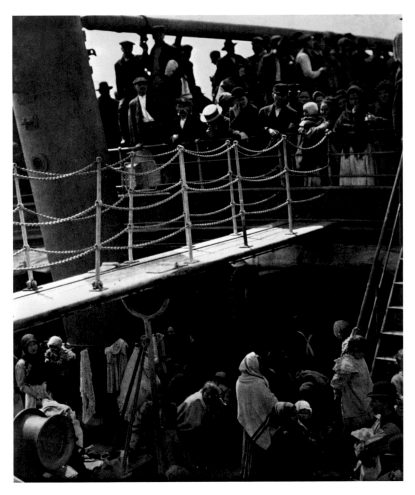

5. Alfred Stieglitz. *The Steerage*. 1907. The Museum of Modern Art, New York. Purchase.

trajectory of his future; in a less admirable way, his plastic sense of history enabled him also to revise his past.

It is in fact not quite possible to believe what Stieglitz says, at least not in any narrow, literal way. He spoke, it would seem, in an experimental mode: trying out one sequence of words to test them against his intuition of some large, semi-effable truth, and then, dissatisfied, using on the next telling a new and somewhat contradictory sequence of words to tell what we would call, for convenience, the same story.

To his most dedicated followers this unwillingness to be cowed by small-minded consistency was a high virtue. Herbert Seligmann said that Stieglitz "might tell a story hundreds of times, but never twice the same. . . . It was as if Stieglitz sought, always with regard to the moment and the degree of understanding of his listeners, to arrive at the very core of the experience he was seeking to make clear. He seized parables out of the immediate day and hour . . . sometimes treating facts allegorically."[21]

It is not altogether clear whether Seligmann means to say that Stieglitz treated facts allegorically or that he treated them casually, but he does seem to be telling us that when we listen to Stieglitz we should try to catch the spirit and not trust too much the letter.

This seems good advice, but difficult to reconcile with the historical method. As an experiment, one might decide to admit as evidence only those of Stieglitz's words that speak in the present tense. Under this rule we would have, for example, nothing from Stieglitz about the making of *The Steerage* of 1907 (fig. 5), on which he seems to have first commented a generation after the negative was made. What we do have, however, is of dubious value: Stieglitz later remembered that he had seen, "A round straw hat, the funnel leaning left, the stairway leaning right, the white draw-bridge with its railings made of circular chains—white suspenders

After the spurt of activity engendered by the Buffalo show, Stieglitz returned to relative quiescence until about 1915. In my view, the work of 1910 records the high-water mark—and the end—of Stieglitz's earlier understanding of the art of photography. The new work begins later, during the war years.

Stieglitz's own comments are not of much help in charting this change in his thought. To Stieglitz it was less admirable to learn than to have always known, and when he changed his mind he characteristically did so retroactively.[20] His rare ability to learn from younger artists meant that he was able repeatedly to revise the

crossing on the back of a man in the steerage below, round shapes of iron machinery, a mast cutting into the sky, making a triangular shape. . . . I saw a picture of shapes and underlying that the feeling I had about life."[22] This seems very much like the description of a picture, not the memory of the experience out of which the picture came. What Stieglitz called a funnel is in fact a mast, a confusion that would hardly be credible if one were recalling the experience.[23]

The evidentiary rule suggested above might help resolve nagging historical difficulties, such as Stieglitz's position toward the idea of "straight photography." In Beaumont Newhall's formulation, straight photography was "the esthetic use of the functional properties of the photographic technique."[24] Newhall went on to say: "Alfred Stieglitz consistently applied this approach to his work. Although he had frequently championed photographers whose prints often resembled paintings and drawings, and although he occasionally made gum prints himself and experimented with other manipulative processes, he preferred all his life to stick closely to the basic properties of camera, lens and emulsion."[25]

In 1978 Weston Naef found, in contrast, that during the decade before 1907 Stieglitz was deeply committed to manipulative processes.[26] It would seem that he made no clear public statement on the superiority of "straight photography" until the comments he made as a juror for the John Wanamaker exhibition of 1913. He said then: "Photographers must learn not to be ashamed to have their photographs look like photographs."[27] This seems unambiguous, but in that competition Stieglitz awarded First Prize to Anne Brigman for her picture *Finis* (fig. 6), demonstrating that although Stieglitz may have adopted a new theoretical position, he was not yet clear about what it might mean in practice. From a mechanical standpoint Brigman's picture might indeed be "straight"; from an artistic standpoint it surely epitomizes—or caricatures—the sodden symbolist posturing that modernism most emphatically rejected.

In 1980 Joel Snyder asked Newhall about the apparent contradiction between his description of Stieglitz's position and the evidence of the photographs themselves:

JS: In The History of Photography, *you say that Stieglitz saw into the heart of the photographic dilemma by the late 1880s, and claim that what distinguished his work from the photographs of most other serious photographers of the time was Stieglitz's commitment to straight photography.*

BN: That's what I say. . . .

JS: But then if you turn to Stieglitz's photographs from this period—including the ones in your book—your narrative runs into some trouble. . . . What makes you say that these pictures are straight photographs?

BN: Well Stieglitz told me they were and I believed him.[28]

Even Beaumont Newhall, a scholar of fastidious intellectual discipline, was capable of being hypnotized by the great American

6. Anne Brigman. *Finis.* c. 1910. The Metropolitan Museum of Art, New York. Alfred Stieglitz Collection.

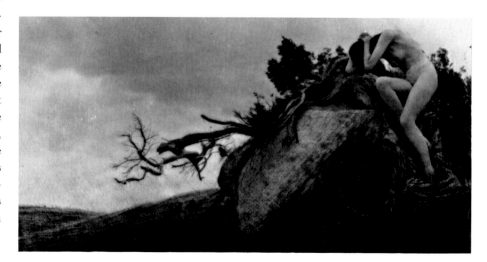

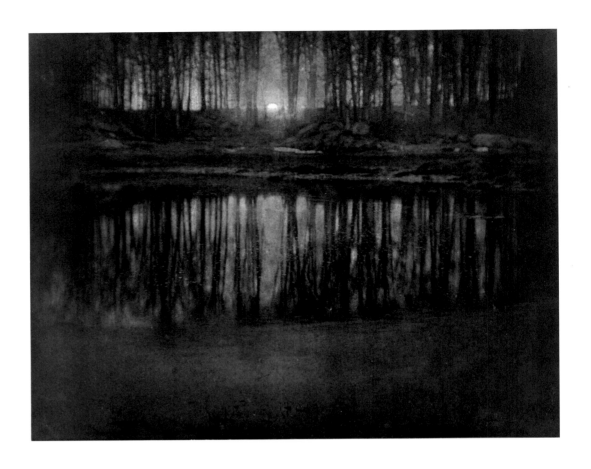

Gurdjieff. But Newhall's credulity seems less remarkable than Stieglitz's sangfroid: his willingness to turn, without a backward glance, away from work and opinions that he had once held so dear. In 1902 he wrote: "It has been argued that the productions of the modern photographer are in the main not photography. While, strictly speaking, this may be true from the scientist's point of view, it is a matter with which the artist does not concern himself."[29] A 1908 letter from Steichen to Stieglitz documents the distance that separated his own practice (fig. 7) from "straight photography" at the time. Strapped for money (as usual during his early years in France), he confessed to Stieglitz that he had avoided paying duty on the photographs that he had sent by declaring them with the factual, but obfuscatory, label *gum-bichromate prints*. He doubted that anyone would recognize them as photographs.[30]

What is at issue here is not the value of one philosophy of photographic technique in comparison to another. The painterly photographic styles of the Edwardian years produced pictures of lasting virtue by photographers such as Heinrich Kühn, Gertrude Käsebier, and most notably Steichen. The motives that produced these pictures are now not easily apprehended, but the prints themselves are at best things of quality, and sometimes of a genuine, if exquisite, beauty. The seriousness with which the best of their makers took these works is expressed eloquently

and unintentionally by Steichen in another letter to Stieglitz, in which he describes the beauty of surface of Constantin Brancusi's marbles in comparison with casts of the same works: "He is just as finicky about quality and finish as we are about prints."[31]

The problems these pictures addressed were problems involving not so much the conventional sentiments that were their nominal subject matter but the control, in vitro, of photographic tonality. This proved inadequately challenging, and by the time of the Great War it was necessary to increase the difficulty of the problem by requiring not only that the photograph be elegant but that it seem to have been made from real life.

To repeat, what is at issue here is not a philosophical but an historical question: What degree of trust should we invest in Stieglitz as autobiographer? The answer would appear to be that we should treat his testimony, and that attributed to him, with greater skepticism than we have in the past.

If it is not easy to understand Stieglitz, one reason may be that he did not cultivate understanding. If the monument by which he is represented to the world is a little incoherent, it is not for that reason a bad likeness. In considering the apparent contradictions in his testimony, it is useful to remember that Stieglitz was unique in the annals of art, I think, in being a major and original figure both as an artist and as an art dealer. I do not believe that either of these groups holds to a higher moral standard than the other, but one might suppose that the nature of their obligations prompts them to serve the truth from rather different perspectives, and that holding both jobs simultaneously could be disorienting.

Stieglitz was an artist of massive self-absorption, and his egocentric and deeply ahistorical definition of the world can be chilling. But what he said should not be permitted to

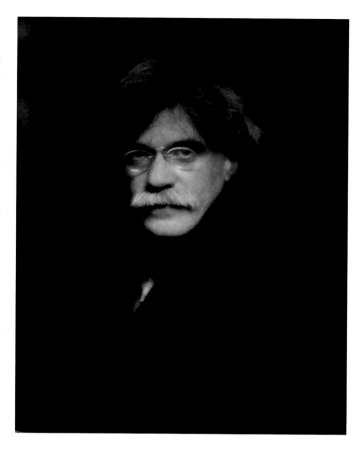

8. Alfred Stieglitz. *Self-Portrait*. 1910. The Museum of Modern Art, New York. Extended Loan from Dorothy Norman.

obscure what he did, which is greater than his explanations of it.

■

The new Stieglitz began to appear around 1915. What might be called a new taste for factuality is seen first in the earliest of the great series of portraits, beginning with Konrad Cramer (1914?), Francis Picabia and Charles Demuth (both 1915), and Marsden Hartley (1915 or 1916). In 1910, in his *Self-Portrait* (fig. 8), Stieglitz was still content to repeat the standard, broad-brush formula of the portrait studio: a disembodied head floats in an undifferentiated sea of gloom, thought to be evocative of Rembrandt. By 1915, in the splendid *Francis Picabia* (fig. 9), we see

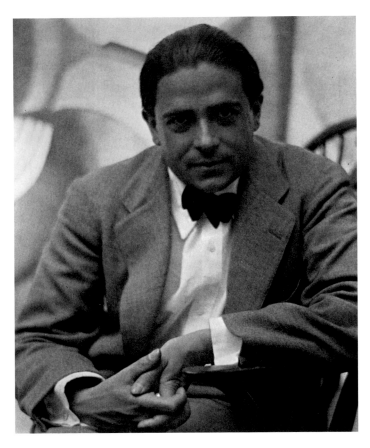

9. Alfred Stieglitz. *Francis Picabia.* 1915. National Gallery of Art, Washington, D.C. Alfred Stieglitz Collection.

the product of a very different, and an enormously more demanding, standard. Now every square inch of the print must do its equal part to create the sense of a seamless and vital reality: the easy softness of the jacket and the plastic completeness of the space (by extension, even the space between Picabia's back and the back of the chair) and the half-anxious poise of his hands, and the tunnel of shirtsleeve from which his right arm projects—these must be described as precisely as the beauty of his face, not perhaps because they are of great importance in themselves, but because they are essential to the success of the illusion, which must be without holes.

The portraits of the mid-teens mark the beginning of a formidable creative effort that continued for more than twenty years, until Stieglitz

finally put down his camera. Mention should also be made of the installation photographs that Stieglitz made of the exhibitions at "291." Surely these are properly looked at first of all as documents serving an instrumental function; nevertheless, in the early war years Stieglitz began to make these photographs not in a perfunctory and dutiful way, as though to record only the gross, approximate facts, but with a new precision and elegance, hoping to make his pictures describe the quality of light and the continuity of the space, and the texture of each object within the frame, and the way in which all of the objects within the frame play against each other to make a satisfactory pattern—a pattern that does not quite contradict, but exists in a temporary truce with the claims of deep space. The record picture of the Picasso-Braque exhibition of 1915 (fig. 10) is one of the most satisfactory of these, and it might have helped persuade Stieglitz that one could make art out of anything one valued.

There are several readily available explanations, none of them mutually exclusive, for the renewed vitality and the new character of Stieglitz's work "toward the end of the 291 days," to use Steichen's dating. The most obvious of these explanations is that Stieglitz finally had time to return to what was perhaps after all his first love—making photographs—since his larger political ambitions had failed or were failing. The Photo-Secession had been effectively dead since the Buffalo show. (It had not been necessary to call a meeting of the board to dissolve the club; it was only necessary for Stieglitz to stop thinking about it.) Stieglitz's great quarterly magazine *Camera Work* was also dying. It has been pointed out often enough that his original audience of pictorialist photographers dropped their subscriptions when confronted with Picasso, Matisse, and Gertrude Stein; it should also be noted that no alternative audience picked up the slack. The magazine's circulation

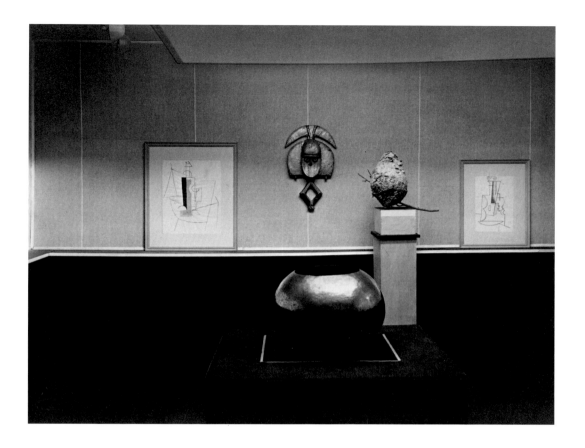

dropped from over 1,000 in 1904 to thirty-six in 1917. And Stieglitz's gallery was also in trouble, especially after the 1913 Armory Show. After often threatening to do so, Stieglitz finally closed the doors of that extraordinary place in June 1917. Stieglitz had certainly not finished his life as a promoter, dealer, and exhorter for modern art, but after this point it seems that he managed to maintain a more effective balance between his life as an artist and his life as an impresario.

The second plausible reason for Stieglitz's leap to a new level of invention is that he had been educated by much of the modernist art exhibited in his gallery, most specifically by the work and ideas of Picasso. It is surely true that Stieglitz's evolving concept of the essential nature of photography was, by about 1915, framed in reference to his own conception of modern painting. Stieglitz called the new painting "anti-photography," and thus declared a theoretical opposite against which his own new intuition of photography could define itself. It was clearly a false dichotomy, but not for that reason less useful. The source of this philosophical position would seem to have been not Picasso but Marius De Zayas, a caricaturist and perhaps chief aesthetician of the Stieglitz group. In 1915, in the short-lived journal *291*, De Zayas wrote a brief essay to accompany a large gravure reproduction of Stieglitz's photograph *The Steerage*. He explained that Stieglitz had surpassed Art and had helped free us from that outmoded concept. Now modern painting would help us comprehend

10. Alfred Stieglitz. *Picasso-Braque Exhibition at "291."* 1915. The Museum of Modern Art, New York. Gift of Charles Sheeler.

the inner world, and photography the objectivity of the outer world. He added that the comprehension of pure objectivity in photography would be possible only if the photographer allowed the camera "full power of expression,"[32] but he did not suggest how that might be done.

We are concerned here, however, not with Stieglitz as a systematic thinker about art, but as an artist: a person who will be forgiven almost any philosophical error if he or she makes wonderful things.

A man of Stieglitz's artistic intelligence could not but be deeply affected by the experience of living as intimately as he did with the works of the great modern pioneers that he exhibited at "291." Nevertheless, appreciation of the extraordinary achievements of one art is not automatically (or even often) translated into great creative strides in another. Stieglitz's knowledge of modern painting was real but vicarious; his knowledge of photography was visceral, and it seems not to have readily absorbed lessons learned by the intellect. If it was Picasso's work that revised Stieglitz's, its effect was curiously slow-acting. Stieglitz had mounted a large show of Picasso's drawings and watercolors in spring 1911, and other varieties of early modernist art had been seen in the gallery earlier: Matisse in 1908; Alfred Maurer, John Marin, and Marsden Hartley in 1909; and Arthur Dove and Max Weber in 1910. But it is difficult to detect any direct transfer of ideas from their work to Stieglitz's, either then or later.[33]

Without doubt, Stieglitz's new pictures after the mid-teens are in some general way informed by a knowledge of the vocabulary of modern painting: they exhibit (with restraint) a heightened awareness of the meaning of the fragmentary and of the elliptical view. And the frequent elimination in his compositions of the stage floor —the ground—produces a greater tension between the picture plane and the described space. These are of course qualities endemic to mod-

ernism; Stieglitz might have learned them from many sources.

It seems most likely, however, that he learned them from the work of Paul Strand, who, earlier than Stieglitz, had internalized the more obvious lessons of cubism and who (rather briefly) made pictures that were unmistakably —in the parochial, high-art sense—modern. In these terms, the pictures that Strand showed Stieglitz in 1915 were more advanced (fig. 11) than anything that Stieglitz had done.[34] Stieglitz himself tells us as much. His praise of the early work of Strand is surely the most extravagant in his long history as a commentator on photography: "In the history of photography there are but few photographers who, from the point of view of expression, have really done work of any importance. . . . The . . . photogravures in this number represent the real Strand. The man who has actually done something from within. The photographer who has added something to what has gone before."[35]

The fact that Strand assimilated (or at least appropriated) cubist tactics earlier and more thoroughly than Stieglitz does not of course mean that he was Stieglitz's equal as an artist. Such a claim would perhaps not be insupportable, but it could surely not be supported on such mechanistic grounds. The question of who first made photographs that consciously made use of cubist solutions is of limited interest— comparable, perhaps, to the question of which modern painter first paid close attention to the accidental double images (two-headed dogs) in early photographs. Surely it has long since been clear that modern painting cannot be defined as "anti-photography," although the influence of photography on painting has surely been substantial. Conversely, modern photography cannot be defined in terms of the use that photographers have made of precedents established in painting. Painting and photography are parts of a larger visual tradition; their concerns and

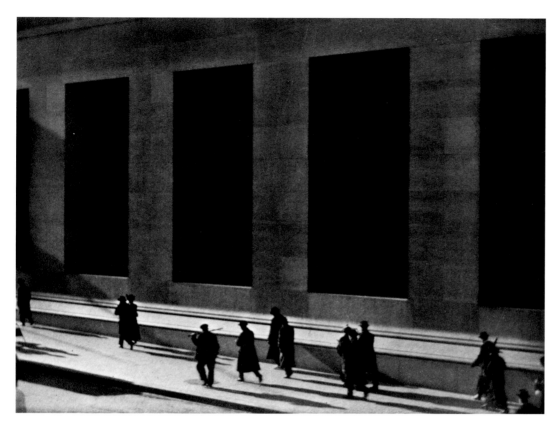

potentials overlap. At times their paths closely parallel each other, but it is also true that each medium expresses exigencies and imperatives that bubble up from pressures formed within.

Thus it is possible to say that Paul Strand's work is more modern than that of Lewis Hine, for example, only if one defines the word modern carefully and narrowly, so that it is clear that one is using the word in a limited art-world context, not a broader cultural one. But even without careful definitions, it is obvious that Strand's pictures are physically more beautiful, more fully considered, more carefully crafted: that is to say, they are more conventionally artistic.

Photography was born modern. Its problem, in relation to the world of high art, was not to become modern, but to become respectable, and it was to this rather servile goal that Stieglitz

dedicated the best of his energies for more than twenty years. But around the age of fifty he seems to have been rescued, partly by the example of Strand's new work and perhaps partly by disillusion, and he was freed to redirect his energies toward a new conception of an art of photography.

■

The pictures that come out of this new conception seem in fact to have little to do with cubism, except perhaps in the sense that the revolution in painting discarded the models that Stieglitz and his friends had been emulating. Stieglitz would not be fooled twice; certainly he would not respond to cubism as the largely talented but intellectually disadvantaged Coburn did—by photographing through a kind of kaleidoscope.

11. Paul Strand. *Wall Street, New York.* 1915. The Museum of Modern Art, New York. Given anonymously.

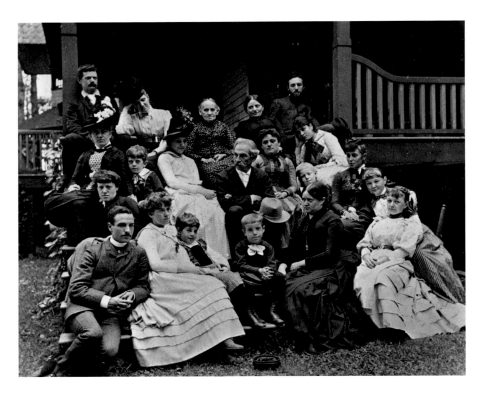

12. Alfred Stieglitz. *Stieglitz Family at Oaklawn.* 1888. Private collection.

Surely the Lake George place itself played a role in the change that came to Stieglitz's work after the Great War. Stieglitz's father Edward had died in 1909, but Oaklawn, his ambitious shingled "cottage" on the lake, was not sold until 1919, the year that Stieglitz and O'Keeffe spent their first summer in the more modest farmhouse on the Lake George property. The farmhouse was white and spare and out of the trees, up on the hill where the air moved freely and more of the sky was visible. On the hill the shapes and textures of man-made things were plain and elemental; character was not the product of a designer's art, but was (in Horatio Greenough's phrase) the record of function. The qualities of Stieglitz's late work are consonant with the qualities of the place, and it is tempting to believe that the place was one of the photographer's teachers.

In his life at Lake George, Stieglitz was comforted by family and servants and depend-

able friends, and was insulated from the emotional risks that attended the competitiveness of life in the city. We might guess that at Lake George not every word, or even every exposure, need be a statement *ex cathedra*, and Stieglitz could unbend a little, take chances, experiment with the idea of what an art of photography might be. He had for years produced the stilted group portraits that recorded which members of the extensive Stieglitz clan were in residence at Oaklawn during one summer or another (fig. 12), but like the early installation views of "291" exhibitions, he would hardly have considered these obligatory family documents works of art. By 1916, however, he was able to regard the casual life of the place as material that could serve his serious artistic ambitions. One day that summer he made at least six extraordinary pictures of Ellen Koeniger finishing her swim in the lake (four of which are reproduced on pages 42–45). In their freedom from pictorial contrivance, these seem unprecedented in Stieglitz's work; in earlier pictures the kinetic element represented one variable note in an otherwise secure and conventional chord. When Stieglitz wrote in 1897 about photography with the hand-held camera he outlined his procedure very clearly: "It is well to choose your subject, regardless of figures, and carefully study the lines and lighting. After having determined upon these watch the passing figures and await the moment in which everything is in balance; that is, satisfies your eye. This often means hours of patient waiting. My picture, 'Fifth Avenue, Winter,' is the result of a three hours' stand during a fierce snowstorm on February 22d, 1893, awaiting the proper moment."[36] This formula would not help him make the Ellen Koeniger pictures; there is here no pattern of "lines and lighting" independent of the image of the swimmer, no architectural context into which the active element can be neatly inserted. The entire subject is in constant flux, and each moment proposes a

new problem. A few years later Stieglitz began to photograph clouds in motion, a variation on the new game which will be considered later.

The portraits that Stieglitz made with the large camera are deliberate, magisterial, rock-solid; Paul Rosenfeld wondered if Stieglitz did not have hypnotic power over his sitters, and the comment seems poetically just. In contrast, some of the best of the snapshots made with the smaller, hand-held Graflex camera are cheerfully centrifugal—only provisionally stable. Sometimes they are blessed with wit, as with the hilarious portrait of Georgia O'Keeffe and Donald Davidson (page 57), in which they seem to have been half transformed by an erratic home-made time machine into Quixote and Dulcinea, he with his armor and lance stolen from the potting shed, she with her conspiratorial smile suggesting that she knows the good knight is slightly off his rocking horse.

The Lake George farm gave Stieglitz a place of freedom and respite, and it gave him also a panoramic reprise of the span of his life. There at the same table were his mother and her nineteenth-century haute-bourgeoise friends, his Edwardian siblings and cousins, his liberated, postwar modernist friends, and the bone-wise, country-bumpkin servants, with their own unstated opinions of the goings-on. "The old horse of 37 was being kept alive by the 70-year-old coachman,"[37] Stieglitz said, and next to the old buggy was his wife's new Ford, a shiny symbol of her independence and his growing isolation.

It is clear that Stieglitz's new life as a photographer had begun before he first met Georgia O'Keeffe in May 1916 and well before the two became lovers, whether that was in 1917 or in 1918.[38] Nevertheless, the rejuvenation of Stieglitz that attended the discovery and exploration of this great and passionate love affair may have contributed to his artistic energy during the following years. Some might even argue that, if O'Keeffe's presence contributed to Stieglitz's

success during the years when they spent their creative summer months together at Lake George, so also her habitual migration to New Mexico, from the early thirties onward, made possible the lonely elegies that Stieglitz produced during his last working years.

Stieglitz's Portrait of O'Keeffe—a series of more than three hundred photographs—was made over a period of two decades, but most of the individual pictures were made in the first years of their affair, when the besotted, insatiable Stieglitz seemed compelled to photograph his lover inch by inch and moment by moment, and across the spectrum of her emotional life. The characteristic pictures of O'Keeffe during 1918 and 1919 comprise a kind of artistic ravishment. There is about them a humid, clandestine, interior quality; often the character of the light suggests that they were made in a tent, perhaps the tent of a barbarian chief. In fact, most of them were made on East Fifty-ninth Street, in the vacant studio of Stieglitz's niece Elizabeth, where O'Keeffe had been temporarily billeted in theoretical propriety.

It is generally, but not always, possible to know whether a given picture of the series was made in New York or in the country, nor can all of the pictures be dated with reasonable confidence. Nevertheless, Benita Eisler is probably correct in estimating that over half of the pictures of the Portrait were made in 1918 and 1919—during O'Keeffe's first two years with Stieglitz.[39] Of the selection of fifty-one pictures reproduced in *Georgia O'Keeffe: A Portrait by Alfred Stieglitz* (1978)[40] twenty-eight were made before 1920.

It is also clear that only a small minority of the early pictures of the Portrait series were made at Lake George, and that even in 1918 these had a character distinct from that of the Fifty-ninth Street pictures. The latter, no matter how intimate, seem in the philosophical sense ideal representations, pictures that describe

woman as artist, woman as fertility goddess, woman as child, woman as man, woman as lover, woman as sacrificial offering, etc., rather than Georgia O'Keeffe of Sun Prairie in various moods and circumstances. In this sense, the early O'Keeffe pictures, in spite of their physical beauty and new formal power, retain a distant but recognizable kinship with the old symbolist female stereotypes of the Photo-Secessionist days. It is perhaps true that the Portrait never rids itself entirely of this mythic overlay, but in the Lake George pictures, even from the beginning, we see the gradual emergence of a subject who serves no fictions but her own. In the late, great pictures of O'Keeffe in her car—liberated, ready to drive off, safe in her machine from his fumbling, irrelevant intimacies, able to look at him now with a kind of disinterested fondness and even with pity—we think we see no synthetic, operatic sentiment, but the truth. These seem pictures made by a photographer who had finally and painfully learned bravery.

Writing of the O'Keeffe Portrait, Paul Rosenfeld seems almost terrified by the atavistic force the pictures embody and the enormity of the demand they express. While acknowledging playful and joyous moments in the work, he emphasizes—rightly, it seems to me—its dark and tormented side, noting the sitter's "irrational hungry demandful eyes. . . . A baffled woeful face. . . . A lioness threatened, proud anger poising on eyes, lips, nostrils; ready to spring."[41]

Rosenfeld was writing before Werner Heisenberg enunciated the uncertainty principle, which stated that the act of measuring a subatomic event changed the nature of the event. Photographers know, to their dismay, that cameras also change the nature of the events they describe. It is not inconceivable that the "baffled woeful face. . ." was in part the expression of a sense of desperation at being unable to escape the constant intrusion of Stieglitz's camera. Her lover's photographic attentions were doubtless flattering up to a point, and few of us are wholly bored by pictures of ourselves, even though most of them show us as less comely than we are in truth. Nevertheless, there is a limit to the amount of time that most of us would wish to spend with a large camera staring at our eyes or navel, especially if we were expected to maintain difficult, unnatural poses —sometimes for a minute or more—without moving.

From 1919 to 1927 Stieglitz and O'Keeffe spent long summers—often five months or more —together at Lake George, but after 1922 (until the end of the decade) additions to the Portrait slowed to a trickle, while Stieglitz concentrated on photographing clouds. It might also be noted that after about 1920 the pictures of the Portrait no longer seem to concern sexual appetite. In the next two or three years this motif continues in pictures of other women: Rebecca Strand, the mysterious Margaret Treadwell, Ida O'Keeffe, Stieglitz's niece Georgia Engelhard, and others, and then subsides until 1930, when Stieglitz begins to photograph Dorothy Norman.

As Stieglitz grew older his photographs described an increasingly personal world. In 1910 he still roamed New York in search of photographs, but when in 1915 he again began to photograph with seriousness he required the subject to come to him. After 1910 he seems not to have made a photograph in New York from sidewalk level, and from that date also he seems not to have photographed a stranger. At thirty-two, Stieglitz said (was quoted as saying): "Nothing charms me so much as walking among the lower classes, studying them carefully and making mental notes."[42] But in fact his photography had never confronted at close range the life of the lower classes. (He had perhaps not confronted the life of *any* class, even

his own, except when, in 1907, he photographed the interior of his father's overstuffed cottage at Lake George; see fig. 13.) He had however explored the life of the street from a cautious middle distance. But after 1910 he photographed a New York empty of people, from his windows above the street: from "291" and from his apartment at the Shelton Hotel and from his last gallery An American Place. Even at Lake George, he photographed only *his* life: his family and staff and friends, his house and barns, his trees and his prospects, and the sky as it could be seen from his hill.

∎

In 1922 Stieglitz began to photograph clouds, and this subject became a major preoccupation that lasted through the rest of the decade and (with diminishing intensity) into the early thirties. In 1923 he wrote an article for the London magazine *The Amateur Photographer and Photography* in which he stated his motive, or rather his several motives, in making these pictures. He made them (1) because he was annoyed at Waldo Frank for having said that his success as a photographer was due to his hypnotic power over his sitters, (2) because he was annoyed at his brother-in-law for having suggested that he had abandoned his interest in music, (3) because he was interested in the relationship between clouds and the world, (4) because he was interested in clouds for themselves, (5) because clouds represented an unusually challenging technical problem, (6) because he wanted to see how much he had learned about photography in forty years (perhaps a restatement of 5), (7) because it was the resumption of a project begun much earlier, and (8) because he wanted by photographing clouds to put down his philosophy of life. It is a characteristic Stieglitz performance: one notion after another is thrown at the question, in the hope that one of them will stick.

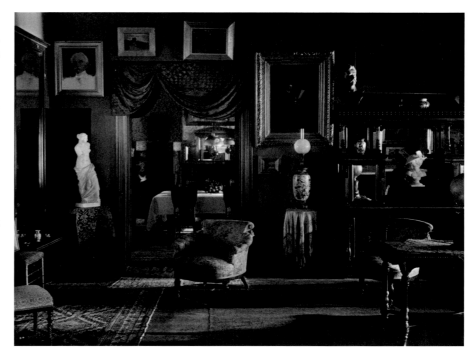

Toward the end of his article Stieglitz included the following passage:

I knew exactly what I was after. I had told Miss O'Keeffe I wanted a series of photographs which when seen by Ernest Bloch (the great composer) he would exclaim: Music! music! Man, why that is music! How did you ever do that? And he would point to violins, and flutes, and oboes, and brass, full of enthusiasm, and would say he'd have to write a symphony called "Clouds." Not like Debussy's but much, much more.

And when finally I had my series of ten photographs printed, and Bloch saw them— what I said I wanted to happen happened verbatim.[43]

Those who can accept without misgivings this claim of miraculous foresight are unlikely to pause to consider whether Stieglitz's eight motives are altogether compatible. In any case,

13. Alfred Stieglitz. *Lake George, Oaklawn*. 1912. National Gallery of Art, Washington, D.C. Alfred Stieglitz Collection.

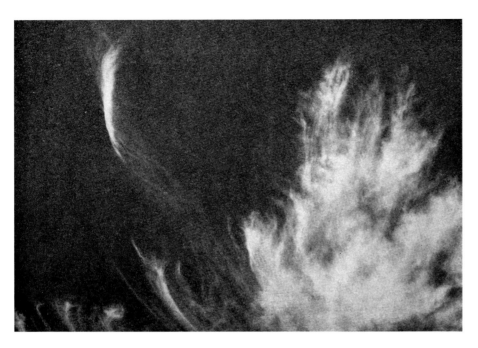

14. F. Ellerman. *Cirrus (plumeus). Seen at Mount Wilson, California.* Published in W. J. Humphreys, *Fogs and Clouds* (1926).

is of interest not because of what he or she has made, but because of what he or she is. In its pop-modern form the proposition says that we are interested in Stieglitz not because he gave us the pictures, but the converse: we are interested in the pictures because they give us Stieglitz. In this formulation, the idea that Stieglitz deserves our interest is a given, a self-evident truth, but self-evident truths have short life expectancies.

The sky was not a new artistic issue. In the early nineteenth century, before the divorce of art and science, painters had detached it from the ground and from traditional landscape stories and sentiments, and had tried to master its every mood and aspect. By 1803 the English chemist Luke Howard—born in 1772, four years before John Constable—had divided clouds into four visual types, and given them Latin names: cirrus, stratus, cumulus, and nimbus, which, with modifiers, they still retain. Clouds were a difficult problem for nineteenth-century photographers, because of the limitations of photographic chemistry. But by the early twentieth century the development of new light-sensitive emulsions made it possible to separate more effectively the cloud from its blue or blue-gray ground, and the sky became a favorite subject. By the twenties photographs of the sky were a standard component of meteorological science, a primitive antecedent of television's nightly satellite weather map.

Figures 14 and 15 reproduce sky photographs made in 1926 or earlier by F. Ellerman and W. J. Humphreys, and included by the latter in his book *Fogs and Clouds*. Humphreys was a professional meteorologist, but he was also an *amateur* of clouds and a collector (as well as a maker) of cloud photographs. In the preface to his book he invites his readers to send him photographs of cloud types that he did not include, or better pictures of the types that he did, assuring them that he will be greatly appreciative, and put their pictures to good

critics have generally resolved Stieglitz's ambivalence by paying little attention to his first seven explanations and concentrating on the eighth, which fits most neatly within the general perception that modern art is concerned with little but personal expression. The idea that a photograph of the sky might be the container, so to speak, of the photographer's spiritual essence —like the powdered bones in a martyr's reliquary—has proven irresistible to otherwise hard-headed critics.

In 1924 or 1925 Stieglitz began to call his sky pictures Equivalents; they were to be seen as the *"equivalents* of my most profound life experience, my basic philosophy of life."[44] The explanation is deeply unsatisfactory, not only because it is unverifiable, but because of its circularity. Stieglitz does not explicitly say that his most profound life experience should be of special interest to those outside of his immediate family, but the claim does seem implicit. A century after the rise of Romanticism, we may have here its purest and most innocent expression: an artist

use.[45] Stieglitz is not known to have responded.

We will doubtless assume that Humphreys and his contributors were interested primarily in clouds for themselves and less in clouds as "*equivalents* of [their] most profound life experience," but perhaps the issue is less clear than we think. Humphreys says: "From delights we fondly cherish to dreads we fain would forget, fog in all its moods and circumstances plays compellingly upon the whole gamut of human emotions."[46]

One way in which Stieglitz's sky pictures were almost surely different than those of W. J. Humphreys and his contributors is that Stieglitz's were realized to a much higher level of craft. Much of Stieglitz's best work as a younger man had begun with his fascination with a difficult technical problem,[47] and in a less obvious way the sky pictures also represented this sort of challenge. The pictures he chose to make almost always represented extreme problems of tonal rendition. On one hand were those subjects where the brightness of the clouds and the sky were very nearly the same; on the other (more difficult) hand were the subjects that included the most extreme range of brightness, even including the disk of the sun. The technical problem might be compared to the problem of scoring a passage of music to secure a clear and appropriate relationship between heavy and delicate sounds. (Stieglitz called his first series of sky pictures *Music—A Sequence of Ten Cloud Photographs*, perhaps in part because he felt the photographic gray scale analogous to the musical scale.) Just as in music there is often more than one soft sound (flutes and violas, say) that must be distinguished from each other as well as from the sharp-voiced oboes and violins, so in photography there are cases (subjects) that demand that the photographer find a way to distinguish between very subtle differences at the light end of the scale, and simultaneously between equally subtle differences at the dark

end.[48] The best way to describe such a subject literally would be in a transparency, such as a stained-glass window or a color slide, since these methods allow, in theory, a virtually infinite scale of brightness. A photographic print, on the other hand, has a very narrow range of reflected brightness; in Stieglitz's sky pictures it is unlikely that the lightest tones are more than twenty times brighter than the darkest tones. Within that narrow range of grays (in a print smaller than a man's hand) the object, one might say, was to make a picture that would suggest the immensities of celestial light and space. Failure was of course the rule.

When Stieglitz spoke to the world at large he spoke with the confidence of Napoleon, and admitted no grounds for doubt. When he spoke to artists whom he trusted and admired he sometimes sounded more like a soldier of the line. His letters to Marin and Dove, especially, do not try to conceal what they already know: that art is hard, that high success is a gift that may be given once and then withheld for years, or perhaps forever, and that there are no trustworthy formulas. The best of these letters are

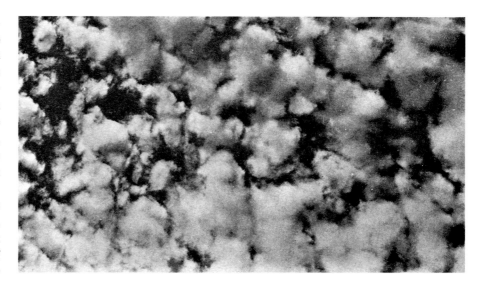

15. W. J. Humphreys. *Alto-cumulus*. Published in W. J. Humphreys, *Fogs and Clouds* (1926).

not Teutonic tirades about art and truth but commentaries on the difficulty—and the occasional excitement—of making a thing well. In 1925, in the middle of the sky picture series, he wrote to Dove: "So far the summer has been unproductive. True, I have a print or two—rather amusing & I haven't the slightest idea what they express! . . . The prints are beautiful nevertheless. So I'm at the game once more—chronic—incurable."[49] (Two years earlier he had written about the cloud pictures for a popular magazine, and had known precisely what they expressed. Stieglitz is in fact consistently a more sympathetic and believable figure when he speaks to those artists in whom he most deeply believes.) In fall 1925 he wrote to Dove again, now in full stride and jubilant: "I've been going great guns & finally feel fit to enjoy activity—lots of it.—And so I'm putting in 18 hours daily—destroying hundreds of prints after making them—keeping few. Eastman is a fiend—& I'm not always Master."[50]

It was habitual for Stieglitz to rail against what he considered the outrageous inadequacy of Eastman Kodak materials, although he continued to use them. What is uncharacteristic is the admission that his technique was not always perfect, a confession that he could perhaps make only to an artist whom he considered his equal.[51]

The outpouring of sky pictures beginning in 1923 relates to a basic change in technique. In 1922 the cloud pictures were made with a view camera, which meant that Stieglitz could not accurately frame his picture if the clouds were moving. (In a view camera one frames the picture on the ground glass, then closes the lens, inserts the film-holder, and removes the dark slide that had protected the film from the light. *Then* one makes the exposure. During the two seconds that have elapsed the clouds have moved.) Stieglitz's 1922 cloud pictures are relatively static, and show for the most part clouds near the horizon, which appear to move

less rapidly than those overhead (moving at right-angles to the picture plane).

From 1923 on Stieglitz did most of his sky pictures with the Graflex—a single-lens-reflex camera in which the image on the ground glass remains visible until the shutter is tripped (fig. 16). With this camera he could frame precisely the clouds as they scuttled across the sky, and he could also point the camera up toward the zenith, an extremely cumbersome and unnatural posture for a view camera. If the camera is pointed straight up, the resulting picture has no natural top or bottom, and can be oriented in any direction. As the camera is lowered toward the horizon, the picture, if rotated away from its natural axis, will acquire subtle tensions with the picture plane, introduced chiefly by the strangeness of the lighting. Stieglitz often did this with his cloud pictures, thus tweaking our aboriginal expectations, and introducing quietly exhilarating or threatening overtones into the picture. Sometimes the device becomes obvious, and therefore a trick.[52]

The disadvantage of the Graflex was that its picture was small—only a quarter the size of the one made by the eight-by-ten view camera—but its advantages were enormous for pictures that could not be studied but must be seized on the wing, without deliberation. Not included among Stieglitz's eight reasons for photographing clouds was the fact that it was fun—similar to, but better than, shooting clay pigeons, since in that game one scores a simple yes or no (the clay saucer is either broken or not); whereas in photographing clouds the result falls on a long and open-ended scale reaching from tedious to electrifying. But it was not Stieglitz's style to admit in public that there was a connection between art and play, even though he had the authority of the great Friedrich Schiller, who said that man was only wholly man when he was playing.[53]

Eventually Stieglitz claimed that all of his

photographs were Equivalents,[54] indicating that in his own view no fundamental distinction should be drawn between the sky pictures and the rest of his work. This view has been generally rejected, and most commentators have viewed the Equivalents as something basically separate from the rest of Stieglitz's oeuvre—a body of work in which he "created an abstract language of form expressive of his subjective state."[55] Stieglitz himself seems ambivalent about the question of abstraction; in a letter to Hart Crane he said: "There is more of the really abstract in some 'representation' than in most of the dead representations of the so called abstract so fashionable now."[56] But it is difficult to be confident that one knows exactly what that means. According to Dorothy Norman, Stieglitz said: "In looking at my photographs of clouds, people seem freer to think about the relationships in the pictures than about the subject-matter for its own sake,"[57] but there is I think no reason to believe he is referring to formal relationships only, nor did he say that people should not think about subject matter, but rather that they should think about it within the reference established by the picture. It is perhaps a tendency of modern criticism to attempt to isolate allusive from formal meanings, but it is surely the central goal of artists to bind them inextricably together. Perhaps Sarah Greenough states the prevailing opinion most cogently in saying that when Stieglitz rotated a picture away from its natural axis he "was emphatically stating that these photographs were not to be understood as documents of the sky, but as artistic statements."[58] I think, rather, that he wanted to make the description of the sky and the artistic statement inseparable.

■

In 1925 Stieglitz wrote to Sherwood Anderson: "I have been looking for years—50 upwards—at a particular sky line of simple hills—how can I tell the world in words what that line is—changing as it does every moment.—I'd love to get down what 'that' line has done for me—May be I have—somewhat—in those snapshots I've been doing the last few years."[59] John Ruskin claimed that there are three types of sensibility: to the first a primrose is simply and unambiguously a primrose; to the second it is not a primrose but something else, perhaps a forsaken maiden; to the third it can contain many other meanings without ceasing to be entirely a

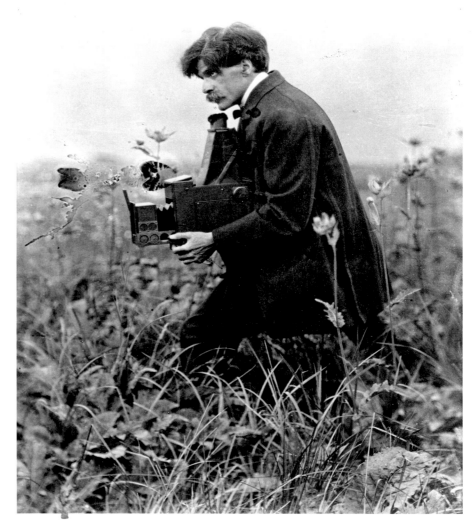

16. Heinrich Kühn. *Alfred Stieglitz with Graflex.* n.d. The Museum of Modern Art, New York. Extended Loan from Dorothy Norman.

primrose.[60] In Ruskin's view the greatest poets were of the third type.

In the late twenties and early thirties Stieglitz directed his camera less often toward the clouds, and more often downward, toward the less dramatically ephemeral creatures of the earth. Among his favorite late subjects were the poplars that stood along the road that led down the hill to the lake. David Travis has pointed out that poplars are not long-lived trees, and that the ones at the Lake George farm had grown old with Stieglitz.[61] Certainly he identified with their dwindling vitality, and their crabbed and desiccated branches; in 1932 he photographed them over and over, as one might check one's pulse, planting his camera almost in the same place, and often framing his negative in almost the same way—trying perhaps for the moment in which the slow-changing structure and the deciduous ornament might show themselves in perfect balance, or the moment in which the dark tops of the leaves and their silver bottoms might vibrate in exact pitch—hoping for some gift, half-earned by half a century of trying, that would allow him to catch the great dying plant in a moment of self-revelation. Then he would print his negatives over and over, lighter and darker and softer and harder, in scores of permutations, trying to make real—make objective—his sense of what these trees were.

Beaumont Newhall said that Stieglitz stopped working about 1937, nine years before his death, because of failing health, and perhaps this was the reason. He had suffered his first severe angina attack (or perhaps heart failure) in 1928,[62] and a decade later he was stricken again, this time almost fatally. A photographer does not need the strength of a stone carver, but not much of value will be done without concentration, which is sometimes a casualty of poor health. Alternatively, perhaps Stieglitz, while photographing the poplars, had remembered what Jonathan Swift had said—that he expected to die like a tree, from the top—and had decided to stop work before the process had advanced too far. Or perhaps he decided that he had spent enough of his life in the darkroom, pursuing a perfect print, and that he would spend as much as possible of his eighth decade in the light. Or perhaps he had photographed everything that he thought necessary. If Stieglitz had given us his own explanation he might have said (after discarding a few experimental reasons that did not have quite the right ring) that his discoveries had become too exciting for his weakened system to bear.

Until he was fifty Stieglitz had worked with great energy and passion in the service of fundamentally conventional ambitions, hoping that he might in this way serve photography and himself. At that point he revised, quickly and thoroughly, his idea of what photography was for. Beginning sometime early in the Great War, it came to Stieglitz that there was nothing that a photograph could not be about, and that there was no special way that a photograph should look. From that point forward he photographed nothing of recognized importance: nothing newsworthy, nothing that could be taken to symbolize the great social or political issues of the time, nothing that might illustrate the sweet hedonistic delights of the twenties or the tragedies of the thirties, all of which go unrecorded in Stieglitz's work. He photographed only subjects that were part of his quotidian life: the great new skyscrapers from his windows in the city, the buildings of the farm on the hill, the sky over his head, his family and servants and the friends and sweet nubile young women who came to visit, and the dying poplars: subjects that were important because he knew them well and wanted to know them better. The best of these pictures are important because they achieve the high goal of art: simply and gracefully they describe experience—knowledge of the world—that we had not known before.

NOTES

1. Mahonri Sharp Young, *Early American Moderns: Painters of the Stieglitz Group* (New York: Watson-Guptill Publications, 1974), pp. 10–11.

2. In 1929 Georgia O'Keeffe made gifts of Stieglitz prints to twelve public institutions (National Gallery of Art and The Phillips Collection, Washington, D.C.; The Museum of Modern Art, New York; Museum of Fine Arts, Boston; George Eastman House, Rochester; The Metropolitan Museum of Art, New York; The Art Institute of Chicago; Fisk University, Nashville; The Library of Congress; Philadelphia Museum of Art; Beinecke Rare Book and Manuscript Library, Yale University, New Haven; San Francisco Museum of Modern Art). The conditions governing these gifts varied from institution to institution, but those covering The Museum of Modern Art are, I believe, in most respects typical. The most restrictive of O'Keeffe's conditions states that the prints cannot be loaned "at any time for any reason to any person or institution, with the exception that for the purpose of the definitive catalogue of Stieglitz prints (now being made by Doris Bry) that I, Doris Bry, or anyone else that I may designate, may remove temporarily any prints necessary for this work." In addition, no "reproductions may be made from the Stieglitz prints except for the purposes of institutional publicity in current magazines or newspapers, or in bulletins of the Museum of Modern Art," except with O'Keeffe's permission.

3. Edward Steichen, *A Life in Photography* (Garden City, N.Y.: Doubleday & Company, 1963), n.p.

4. Sue Davidson Lowe, *Stieglitz: A Memoir/Biography* (New York: Farrar, Straus and Giroux, 1983), p. 50.

5. F. Austin Lidbury, "Some Impressions of the Buffalo Exhibition," *American Photography* 22, no. 12 (December 1910), pp. 676–681. Quoted in Peter Bunnell, *A Photographic Vision: Pictorial Photography, 1889–1923* (Salt Lake City: Peregrine Smith, 1980), p. 182.

6. See Dorothy Norman, *Alfred Stieglitz: An American Seer* (New York: Aperture and Random House, 1973), p. 46.

7. Sadakichi Hartmann, "What Remains," *Camera Work*, no. 33 (January 1911), p. 31.

8. Alfred Stieglitz to Ernst Juhl, January 6, 1911. Alfred Stieglitz Archive, Collection of American Literature, Beinecke Rare Book and Manuscript Library, Yale University, New Haven. Quoted in Sarah Greenough and Juan Hamilton, *Alfred Stieglitz: Photographs and Writings* (Washington, D.C.: National Gallery of Art, 1983), p. 193, n. 18.

9. Edward Steichen to Alfred Stieglitz, November 1910. Alfred Stieglitz Archive, Yale University, letter no. 274; see also undated letters, nos. 226–227, 257–261, 347–349. Photocopies in the Edward Steichen Archive, Department of Photography, The Museum of Modern Art, New York.

10. Herbert J. Seligmann was a free-lance critic whose professional obligations were not so demanding that they prevented him from visiting Stieglitz's gallery fifty-nine times in 1926. None of these visits seems to have occurred during the unusually long vacation season, from May through October. His devotion continued until 1931, although with progressively diminishing constancy. In that year only three visits are recorded, the last on May 26, just before the long Decoration Day weekend. See Herbert J. Seligmann, *Alfred Stieglitz Talking* (New Haven: Yale University Library, 1966).

11. According to Steichen, Stieglitz did not appreciate his most famous picture either, until persuaded by Marius De Zayas. See Edward Steichen, *A Life in Photography* (New York: Doubleday & Company in collaboration with The Museum of Modern Art, 1963), before pl. 44.

12. Steichen had returned from France to the United States in 1923, to assume the title of "The Greatest Living Portrait Photographer," bestowed on him by Frank Crowninshield, the editor of *Vanity Fair*, who hired Steichen to be the magazine's chief photographer.

13. Alfred Stieglitz, "The Photo-Secession," *Camera Work*, no. 3 (July 1903), p. 5.

14. Alfred Stieglitz to Paul Strand, August 11, 1919. Center for Creative Photography, The Paul Strand Collection, University of Arizona, Tucson. Quoted in Greenough and Hamilton, *Photographs and Writings*, p. 205.

15. John Quinn to Augustus John, June 15, 1910. The John Quinn Memorial Collection, Rare Books and Manuscripts Division, New York Public Library, Astor, Lenox, and Tilden Foundations. Quoted by Judith Zilczer in "Alfred Stieglitz and John Quinn: Allies in the American Avant-Garde," *American Art Journal* 17, no. 3 (Summer 1985), p.19.

16. The pictures of 1910, as listed in the exhibition catalogue, were *The Aeroplane; The Dirigible; The City of Ambitions; Lower Manhattan; Outward Bound, The "Mauretania"; The City Across the River; Old and New New York, 34th Street;* and *After Working Hours, The Ferry Boat.*

17. "My career in photography can be said to date from the day I entered Professor Vogel's course in 1883." Alfred Stieglitz, quoted in Norman, *An American Seer*, p. 26.

18. Greenough and Hamilton, *Photographs and Writings*, published in conjunction with the exhibition *Alfred Stieglitz*, organized by the National Gallery of Art, Washington, D.C., in 1983.

19. After Stieglitz's death most of the photographs remaining in his hands were divided by Georgia O'Keeffe into twelve groups and given to public institutions (see note 1). It has been generally assumed that the best print was given to the National Gallery of Art, Washington, D.C.

20. Perhaps the most notable exception to the rule is Stieglitz's 1897 article, "The Hand Camera—Its Present Importance," *The American Annual of Photography and Photographic Times Almanac for 1897* (1897), pp. 19–27. Reprinted in Greenough and Hamilton, *Photographs and Writings*, pp. 182–184. In this essay Stieglitz confesses that he had not earlier recognized the potential of the hand camera, but adds that it was because of the misleading information published by the camera's manufacturers.

21. Seligmann, *Alfred Stieglitz Talking*, p. viii.

22. Alfred Stieglitz, "How *The Steerage* Happened," *Twice a Year*, nos. 8–9 (1942), p. 128.

23. I am indebted to Frank Trumbour, an authority on ocean liners, for the identification of the parts of the ship visible in *The Steerage*.

24. Beaumont Newhall, *The History of Photography: From 1839 to the Present Day* (New York: The Museum of Modern Art, 1949), p. 143. Newhall's full definition continues: "The appreciation of both the camera's potentialities and its limitations, and the divorce of photography from the canons guiding the esthetic principles of graphic art—was not so much discovery as the recognition of traditions as old as photography itself." The passage is repeated with minor changes in the 1964 edition, but is substantially modified in that of 1982.

25. Ibid.

26. Weston J. Naef, *The Collection of Alfred Stieglitz: Fifty Pioneers of Modern Photography* (New York: The Metropolitan Museum of Art and Viking Press, 1978), p. 214.

27. See *Photo-Miniature* 11 (March 1913), p. 220. Quoted in Mary Panzer, *Philadelphia Naturalistic Photography: 1865–1906* (New Haven: Yale University Art Gallery, 1982), p. 22.

28. Joel Snyder to John Szarkowski, September 18, 1994.

29. Alfred Stieglitz, "Modern Pictorial Photography," *The Century Magazine* 64 (October 1902), p. 825.

30. Edward Steichen to Alfred Stieglitz, 1908. Alfred Stieglitz Archive, Yale University, letter no. 135. Photocopy in Edward Steichen Archive, The Museum of Modern Art.

31. Edward Steichen to Alfred Stieglitz, April 8, 1913. Alfred Stieglitz Archive, Yale University, letter no. 163. Photocopy in Edward Steichen Archive, The Museum of Modern Art.

32. Marius De Zayas, in *291*, nos. 7–8 (September–October 1915), n.p.

33. One might make an exception of *The Steerage*. Dorothy Norman quotes Stieglitz as saying of this remarkable photograph: "If all my photographs were lost and I were represented only by *The Steerage*, that would be quite all right" (Norman, *An American Seer*, p. 77). But he said that twenty-odd years after the fact. The negative was made in 1907, under circumstances that Stieglitz did not clearly remember, but in 1910 he did not consider it worthy of inclusion among the twenty-nine pictures that he chose for the big Buffalo show. Apparently, it was first seen in the October 1911 issue of *Camera Work*, after (according to Steichen) Marius De Zayas persuaded Stieglitz that it was good enough.

34. According to Nancy Newhall, the group included *Wall Street, New York*, and unidentified pictures from Strand's early street portraits, perhaps including the woman with the flowered hat, which Newhall dates as 1915, not 1916, the date recently favored. See Nancy Newhall, *Paul Strand* (New York: The Museum of Modern Art, 1945), p. 4.

35. Alfred Stieglitz, "Our Illustrations," *Camera Work*, nos. 49–50 (June 1917), p. 36.

36. Stieglitz, "The Hand Camera—Its Present Importance." Quoted in Greenough and Hamilton, *Photographs and Writings*, p. 184.

37. Alfred Stieglitz, "How I Came to Photograph Clouds," *Amateur Photographer and Photography* (September 19, 1923), p. 255. Quoted in Greenough and Hamilton, *Photographs and Writings*, p. 207.

38. Benita Eisler says it was "most probably" 1917, for reasons that are perhaps intuitive. See Benita Eisler, *O'Keeffe and Stieglitz: An American Romance* (New York: Doubleday & Company, 1991), p. 183 and n. 4.

39. Ibid.

40. *Georgia O'Keeffe: A Portrait by Alfred Stieglitz*. Introduction by Georgia O'Keeffe (New York: The Metropolitan Museum of Art, 1978).

41. Paul Rosenfeld, "Alfred Stieglitz," in *Port of New York* (New York: Harcourt, Brace & Company, 1924), pp. 275–277. First published in *The Dial* 70 (1921), pp. 397–409. Reprinted in Beaumont Newhall, ed., *Photography: Essays and Images* (New York: The Museum of Modern Art, 1980), pp. 209–218.

42. "Alfred Stieglitz and His Latest Work," *The Photographic Times*, no. 27 (April 1896), p. 161.

43. Stieglitz, "How I Came to Photograph Clouds," p. 255. Quoted in Greenough and Hamilton, *Photographs and Writings*, p. 207.

44. Norman, *An American Seer*, p. 144.

45. W. J. Humphreys, *Fogs and Clouds* (London: Baillière, Tindall & Cox; Baltimore: Williams & Wilkins, 1926), pp. xv–xvii.

46. Ibid., p. 30.

47. *Winter, Fifth Avenue* and *The Terminal* (both 1893) are conspicuous examples of Stieglitz's technical adventurousness. In the case of *Winter, Fifth Avenue*, he took delight in repeating the story of a fellow Camera Club member who considered the negative to be unprintable. See Stieglitz, "The Hand Camera—Its Present Importance."

48. The fundamental technical problem in conventional (metallic salt-based) photography—the relationship of density to exposure and development—was rationalized in 1890 by Ferdinand Hurter and Vero Charles Driffield. In what came to be called the H&D curve (or the characteristic curve) of a particular emulsion, exposure was plotted on the X axis and density on the Y axis. In the central (straight-line) position of the curve, equal increments of exposure produced equal additions to density. The steepness of the curve (given the same subject and emulsion) indicated the degree of contrast added by development. The photographer worked within, or somehow evaded, these basic rules.

49. Alfred Stieglitz to Arthur Dove, July 7, 1925. Quoted in Ann Lee Morgan, ed., *Dear Stieglitz, Dear Dove* (Newark: University of Delaware Press; London and Toronto: Associated University Presses, 1988), p: 115.

50. Alfred Stieglitz to Arthur Dove and Reds Torr, November 9, 1925. Quoted in ibid., pp. 118–119.

51. Many of Stieglitz's technical problems at Lake George were perhaps traceable to his very primitive darkroom, which seems to have had no hot water supply. As a former student of photographic technology under the famous Professor Hermann W. Vogel, Stieglitz surely understood clearly that his chemical solutions would not work as intended at 50° F., and he doubtless made adjustments. He may have also believed, at a deeper level of knowing, that the ordinary laws of chemistry did not precisely apply to him.

52. In the Equivalents, Stieglitz was perhaps the most conspicuous camera tilter before Garry Winogrand, who liked to deny that his pictures were tilted, by which he surely meant that the forms within the picture were always considered in relationship to the picture's edges.

53. Friedrich Schiller, *On the Aesthetic Education of Man in a Series of Letters*. Translation by Reginald Snell (New Haven: Yale University Press, 1954), p. 80.

54. Norman, *An American Seer*, p. 144.

55. Sarah Eden Greenough, "Alfred Stieglitz's Photographs of Clouds." (Ph.D. diss., The University of New Mexico, Albuquerque, 1984), p. 1.

56. Alfred Stieglitz to Hart Crane, December 10, 1923. Hart Crane Papers, Columbia University Library, New York. Photocopy in Alfred Stieglitz Archive, Yale University. Quoted in Greenough and Hamilton, *Photographs and Writings*, p. 208.

57. Norman, *An American Seer*, p. 161.

58. Greenough, "Alfred Stieglitz's Photographs of Clouds," p. 158.

59. Alfred Stieglitz to Sherwood Anderson, July 5, 1925. Alfred Stieglitz Archive, Yale University. Quoted in Greenough and Hamilton, *Photographs and Writings*, p. 210.

60. John Ruskin, *Modern Painters*. Vol. 3, 1856 (London: Andre Deutsch Limited, 1987), p. 365.

61. David Travis, "Beyond Virtuosity." (Lecture presented at The Phillips Collection, Washington, D.C., March 16, 1993).

62. See Lowe, *A Memoir/Biography*, p. 290.

PLATES

Carriage and Barn, Lake George. c. 1922

Mrs. Hedwig Stieglitz. c. 1920

Shadows on the Lake—Stieglitz and Walkowitz. 1916

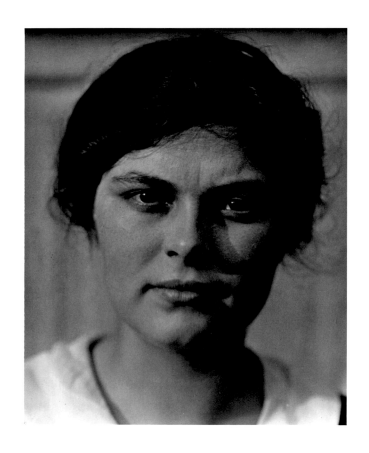

Portrait of a Woman, Lake George. Probably 1920–21

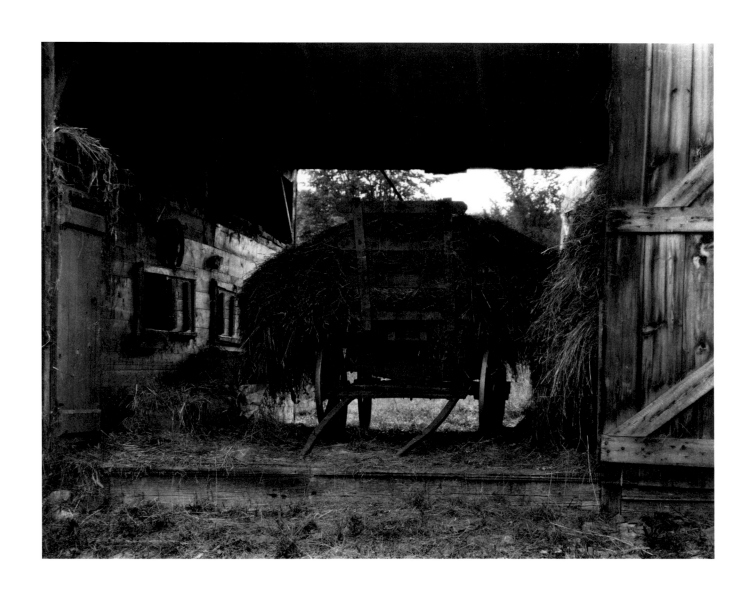

Hay Wagon, Lake George. 1923

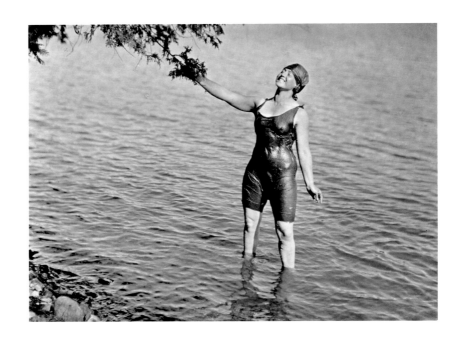

Ellen Koeniger, Lake George. 1916

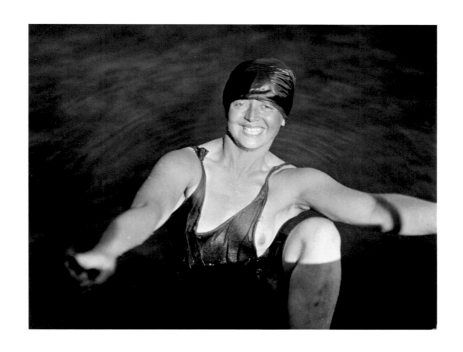

Ellen Koeniger, Lake George. 1916

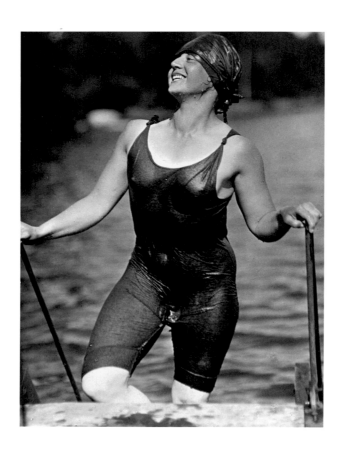

Ellen Koeniger, Lake George. 1916

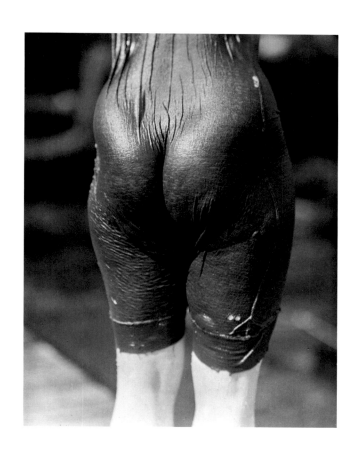

Ellen Koeniger, Lake George. 1916

Lake George. 1920s

Mrs. Hedwig Stieglitz and Katherine Herzig, Lake George. Probably 1920

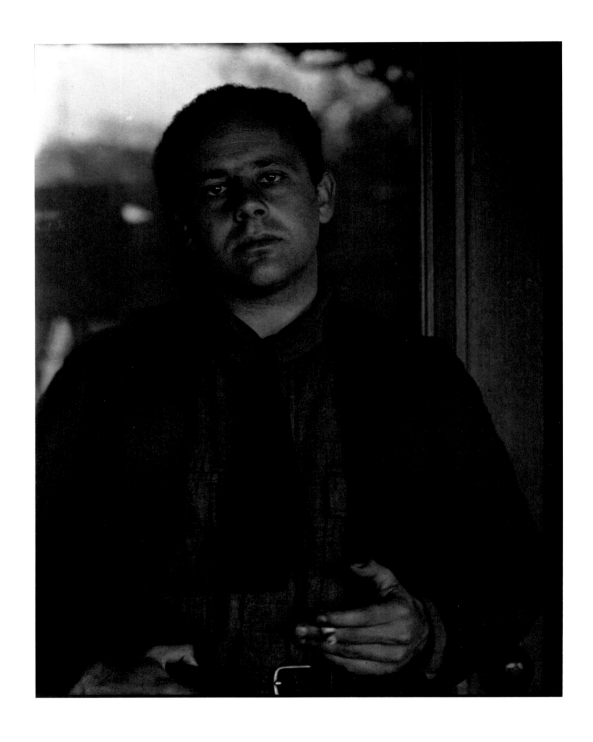

Paul Strand. 1919.

Georgia O'Keeffe. 1918

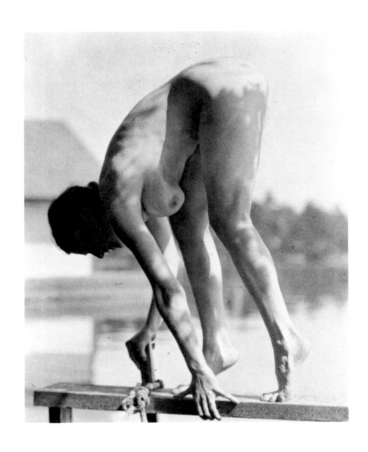

Rebecca Salsbury Strand. 1923

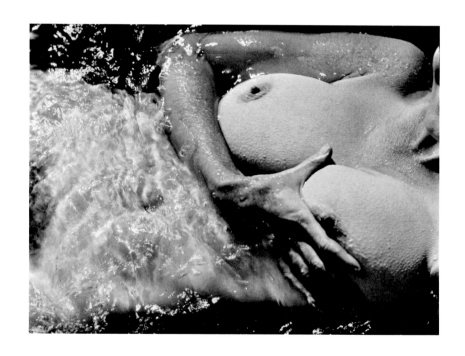

Rebecca Strand. 1923

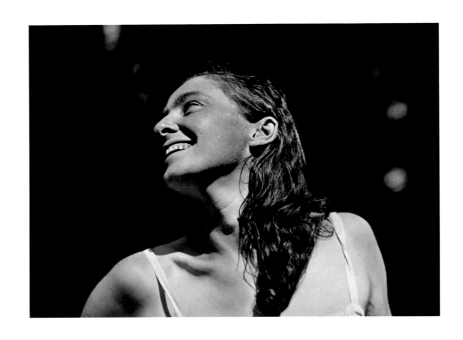

Rebecca Salsbury Strand. 1923

Georgia O'Keeffe. 1921

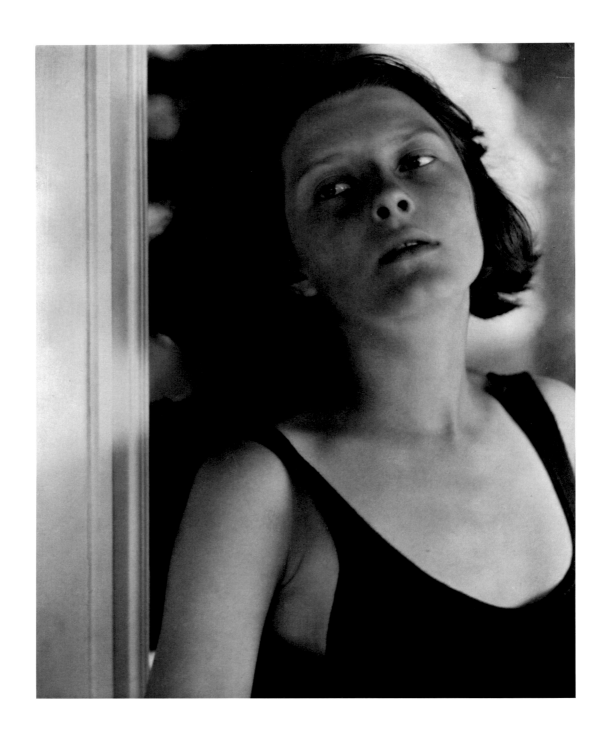

Margaret Treadwell. 1921

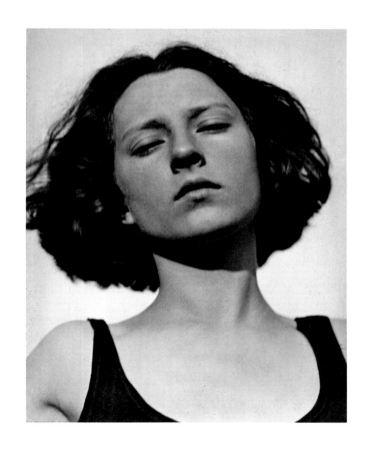

Margaret Treadwell. 1921

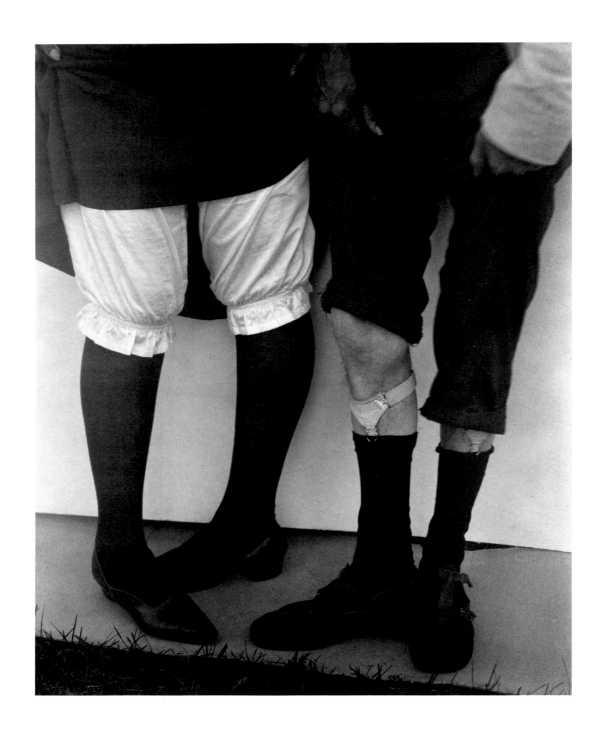

Legs, Elizabeth and Donald. 1921

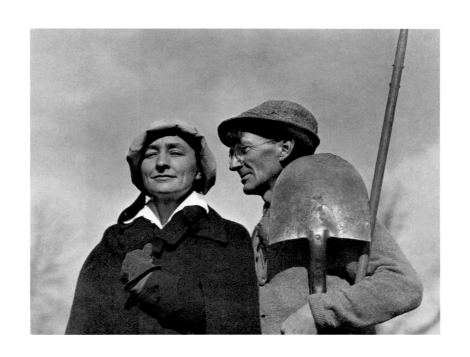

Georgia O'Keeffe: A Portrait—with Donald Davidson. 1924

George and Yvonne Boursault, Lake George. 1923

Jerome Mellquist and Paul Rosenfeld, Lake George. 1932

Lake George. 1922

Georgia Engelhard. 1921

Georgia O'Keeffe. 1933

Waldo Frank. 1920

Portrait. 1922

Apple and Drops of Rain. 1922

Georgia O'Keeffe: A Portrait—Head. 1920

Music—A Sequence of Ten Cloud Photographs, No. I. 1922

Spiritual America. 1923

Lake George. 1921

Music—A Sequence of Ten Cloud Photographs, No. VIII. 1922

Music—A Sequence of Ten Cloud Photographs, No. IV. 1922

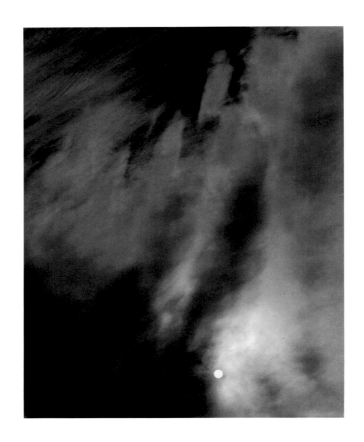

An Equivalent in a Series of Two Equivalents, Print Y. 1923–38

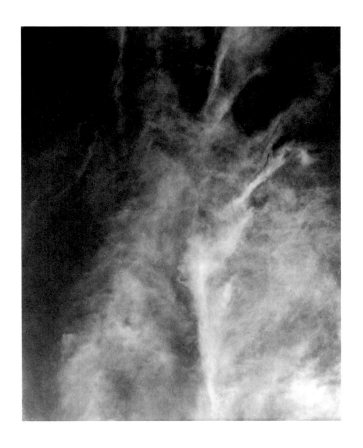

An Equivalent in a Series of Two Equivalents, Print X. 1923–38

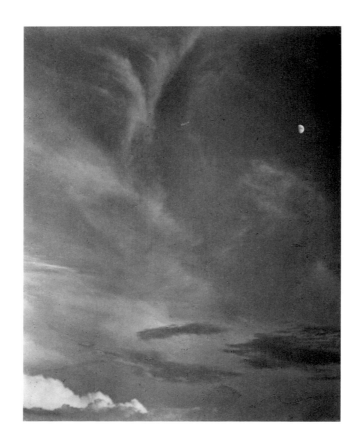

Equivalent. 1931

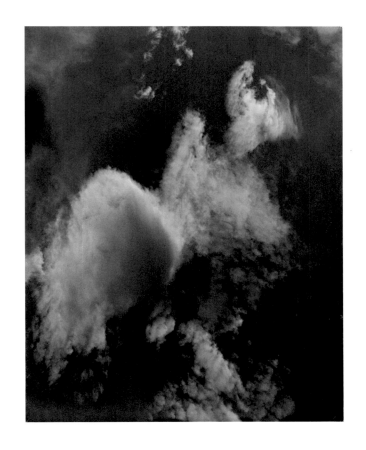

Equivalent. 1925

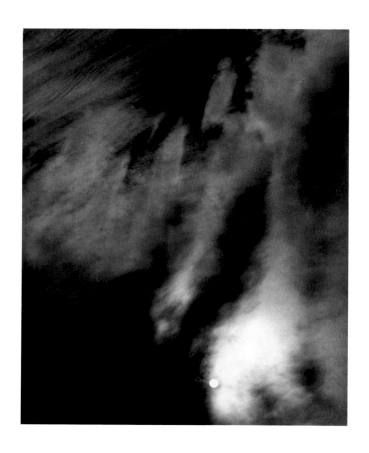

Equivalent. 1925–35

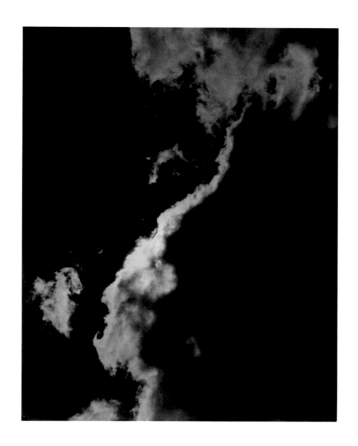

Songs of the Sky. 1923

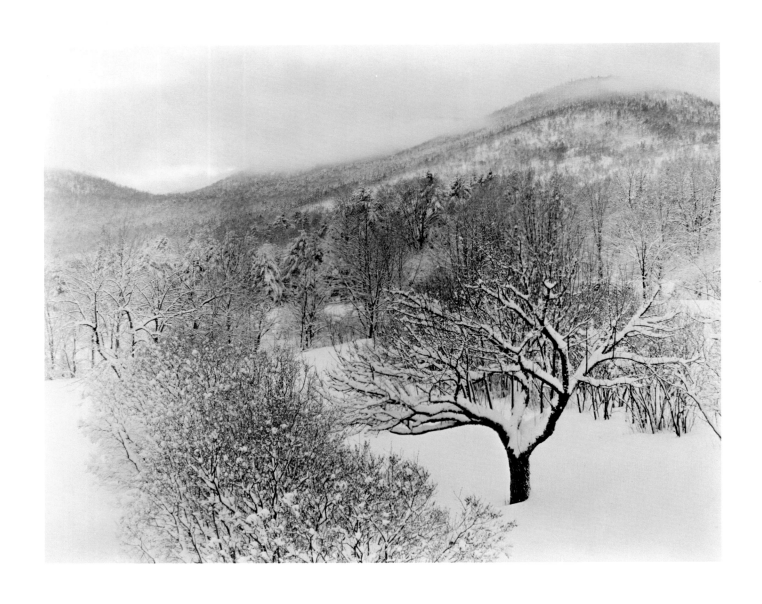

Lake George in Winter. 1923

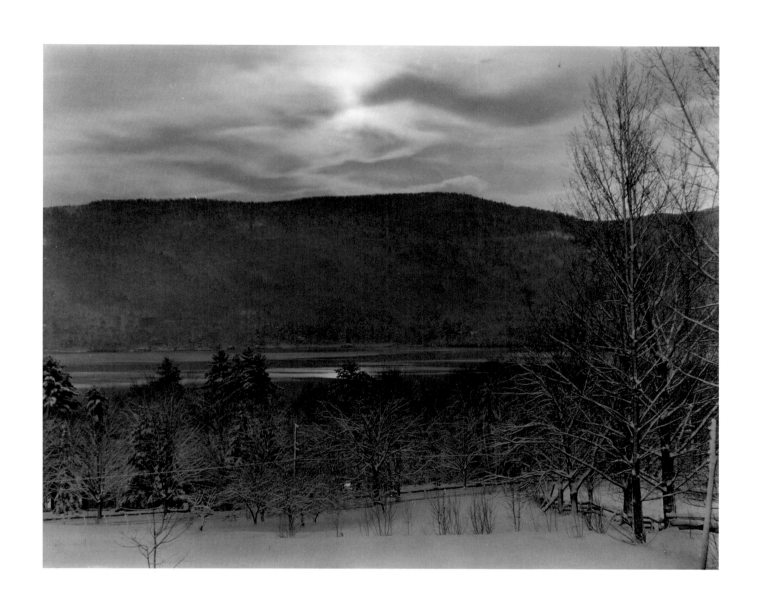

Lake George in Winter. 1923

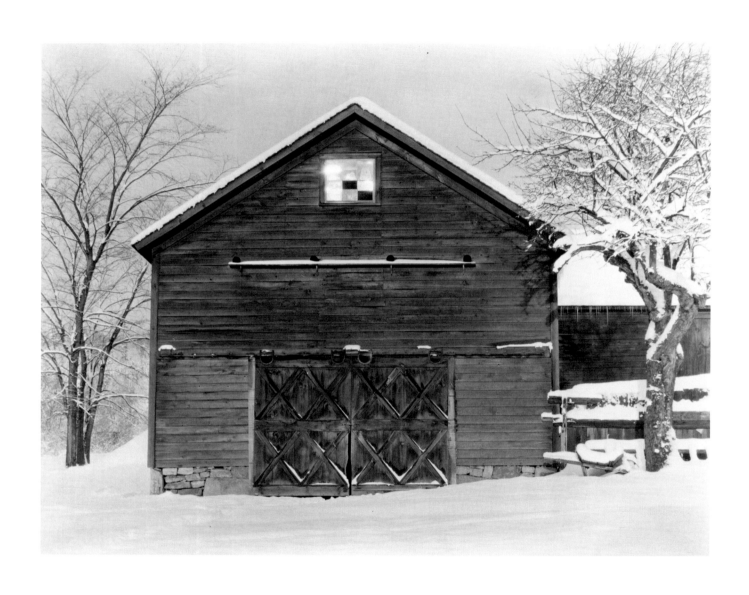

Barn in Winter, Lake George. 1923

Lake George. 1923

Barns, Lake George. 1923

First Snow and the Little House. 1923

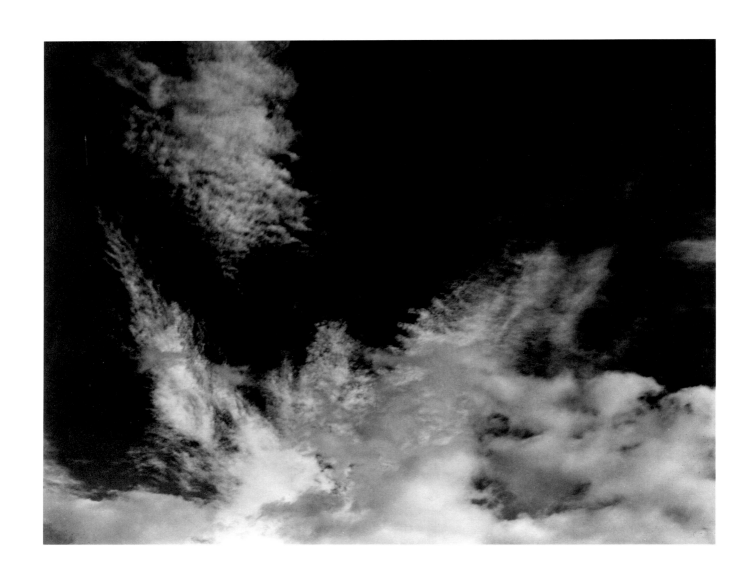

Equivalent. 1929

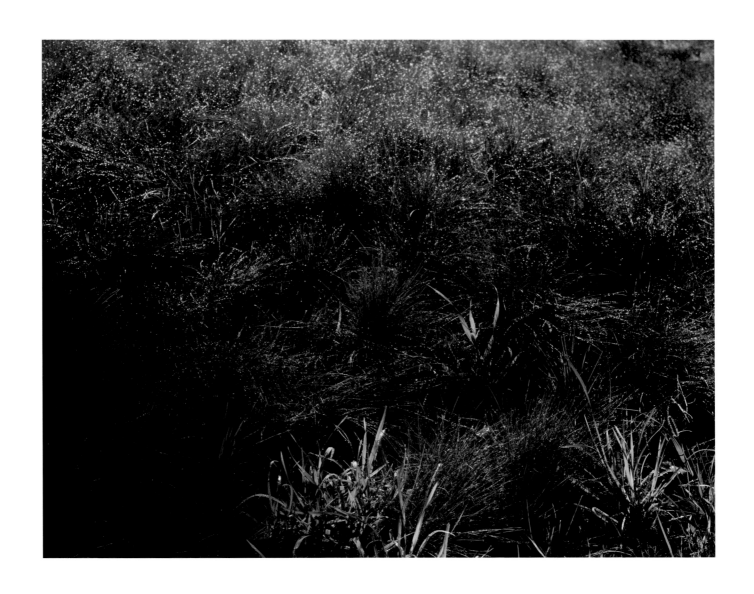

Lake George. 1933–34

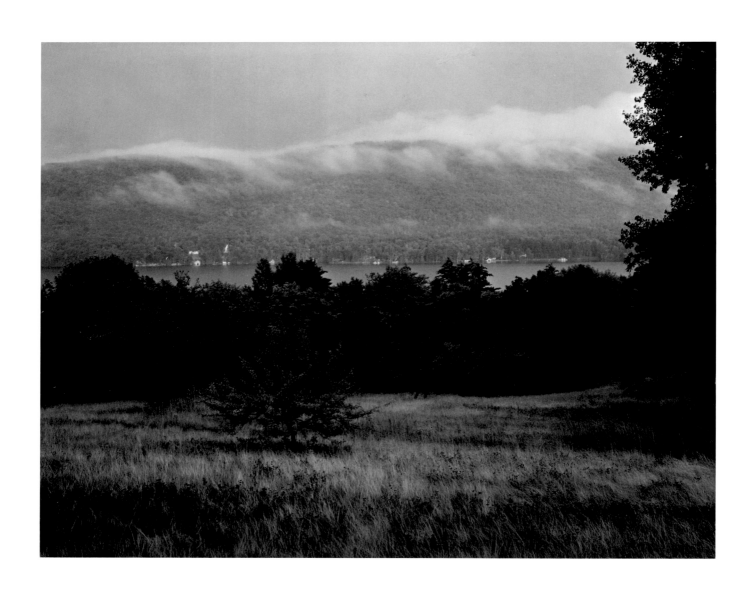

Lake George. 1931

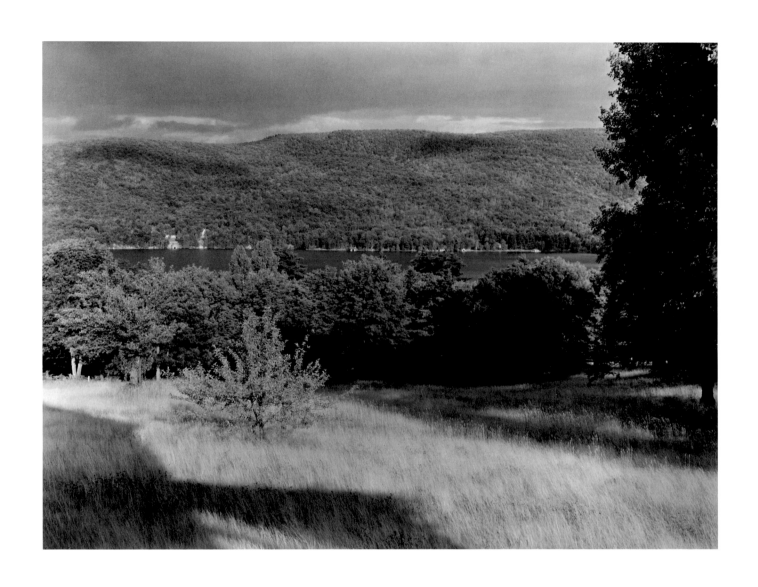

Lake George. 1931

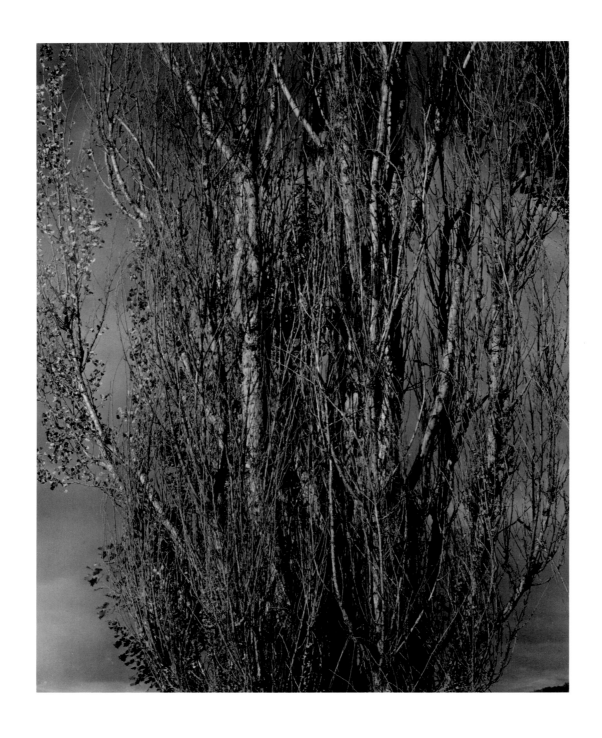

Lake George. 1932

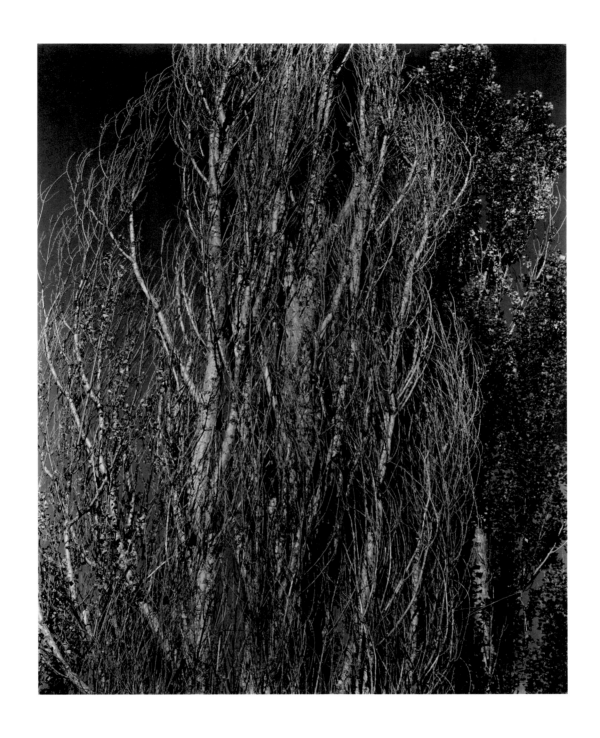

Lake George. 1932

Georgia O'Keeffe: A Portrait. 1933

Moon. c. 1926

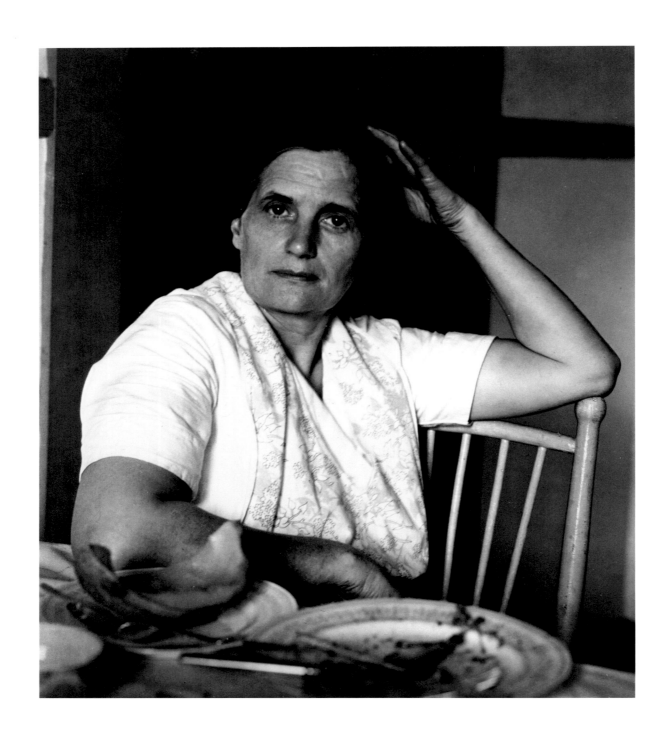

Margaret Prosser. 1936

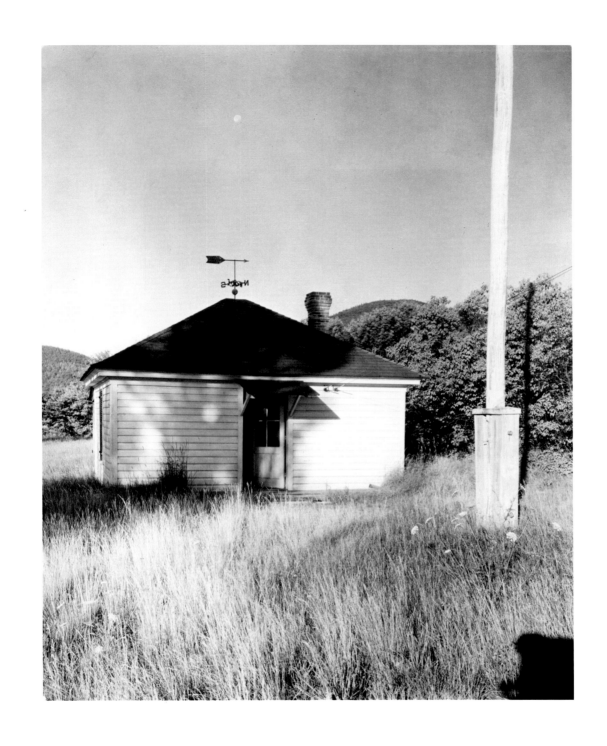

Little House, Lake George. Probably 1934

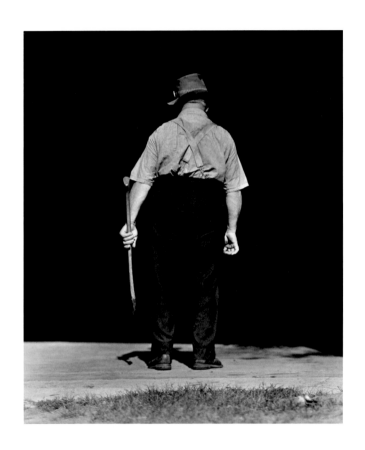

Richard. 1931

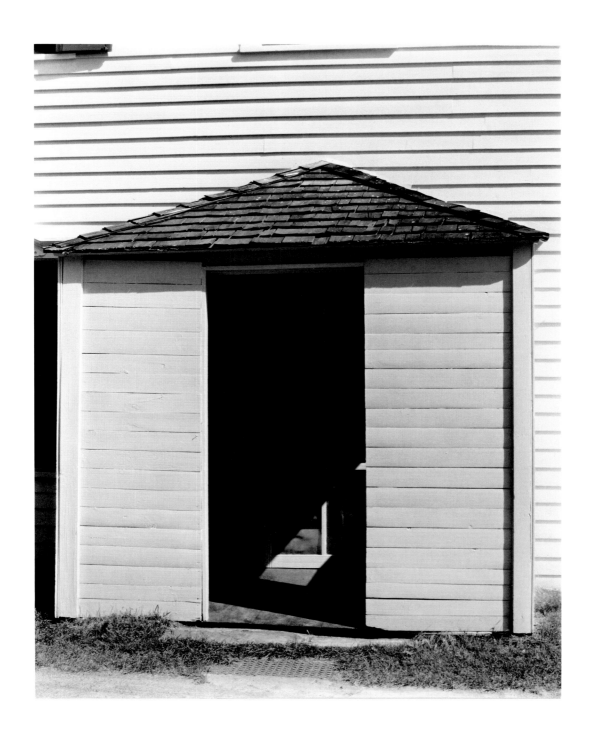

Door to Kitchen. 1934

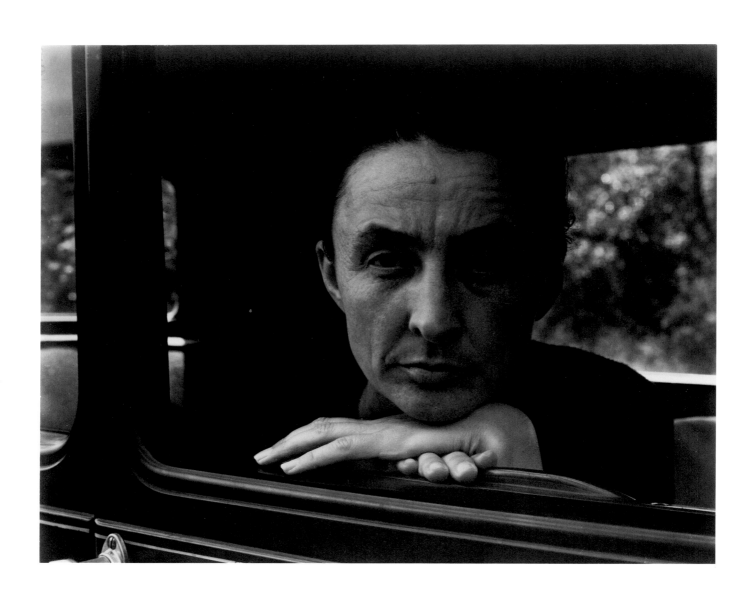

Georgia O'Keeffe. 1931

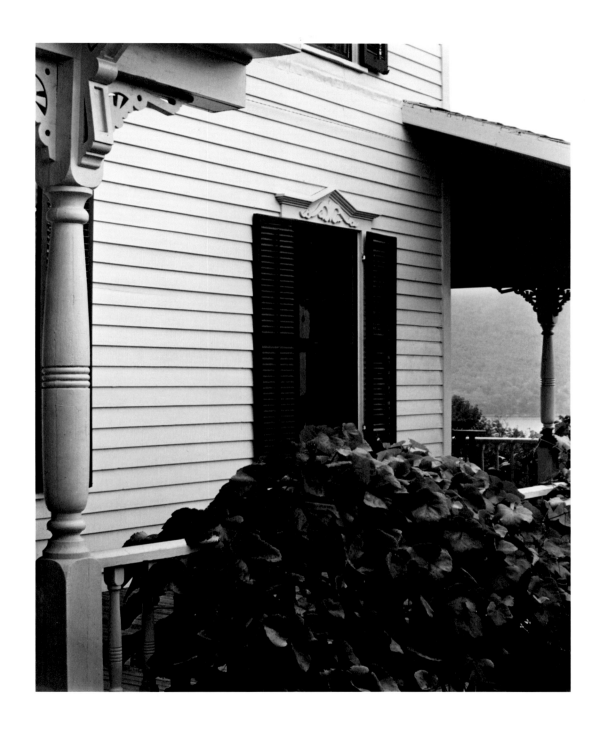

House and Grape Leaves. 1934

Car 2F 77-77. 1935

CATALOGUE OF THE EXHIBITION

Note: Dimensions are given in inches and centimeters, height preceding width. Plate illustrations are indicated by page numbers at the end of the catalogue entries; the remaining works are illustrated with the entries.

Ma. 1914
Platinum print. 9⅞ x 7⅞" (25.1 x 20 cm).
The Art Institute of Chicago. The Alfred Stieglitz Collection

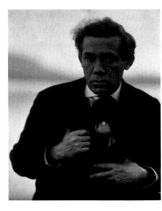

Abraham Walkowitz, Lake George. c. 1915
Gelatin-silver print. 9⅝ x 7⅝" (24.3 x 19.3 cm).
The Museum of Modern Art, New York. Gift of Abraham Walkowitz

Ellen Koeniger, Lake George. 1916
Gelatin-silver print. 4⁵⁄₁₆ x 3⅛" (10.9 x 8 cm).
National Gallery of Art, Washington, D.C.
Alfred Stieglitz Collection
Page 44

Ellen Koeniger, Lake George. 1916
Gelatin-silver print. 4⁹⁄₁₆ x 3½" (11.6 x 8.9 cm).
National Gallery of Art, Washington, D.C.
Alfred Stieglitz Collection
Page 45

Ellen Koeniger, Lake George. 1916
Gelatin-silver print. 3½ x 4⅝" (8.8 x 11.7 cm).
The Museum of Modern Art, New York.
The Alfred Stieglitz Collection, gift of Georgia O'Keeffe
Page 42

Ellen Koeniger, Lake George. 1916
Gelatin-silver print. 3½ x 4⅝" (8.8 x 11.7 cm).
The Museum of Modern Art, New York.
The Alfred Stieglitz Collection, gift of Georgia O'Keeffe
Page 43

Shadows on the Lake—Stieglitz and Walkowitz. 1916
Gelatin-silver print. 4⅜ x 3½" (11.3 x 8.9 cm).
National Gallery of Art, Washington, D.C.
Alfred Stieglitz Collection
Page 39

Georgia O'Keeffe. 1918
Gelatin-silver print. 3⁹⁄₁₆ x 4⁹⁄₁₆" (9.1 x 11.6 cm).
San Francisco Museum of Modern Art. Gift of Georgia O'Keeffe, Alfred Stieglitz Collection
Page 49

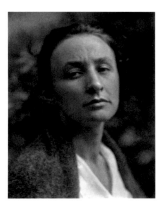

Georgia O'Keeffe: A Portrait. 1918–19
Gelatin-silver print. 4⅜ x 3½" (11.1 x 8.9 cm).
National Gallery of Art, Washington, D.C.
Alfred Stieglitz Collection

Paul Strand. 1919
Palladium print. 9⅝ x 7⅝" (24.5 x 19.5 cm).
National Gallery of Art, Washington, D.C.
Alfred Stieglitz Collection
Page 48

Georgia O'Keeffe: A Portrait. 1920
Palladium print. 8 x 9⅞" (20.3 x 25.1 cm).
The J. Paul Getty Museum. The Alfred Stieglitz Collection

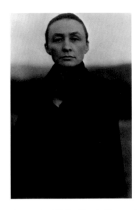

Georgia O'Keeffe: A Portrait. 1920
Gelatin-silver print. 8¼ x 5¼" (21 x 13.3 cm).
National Gallery of Art, Washington, D.C.
Alfred Stieglitz Collection

Georgia O'Keeffe: A Portrait—Head. 1920
Gelatin-silver print. 9⁹⁄₁₆ x 7⁹⁄₁₆" (24.3 x 19.2 cm).
National Gallery of Art, Washington, D.C.
Alfred Stieglitz Collection
Page 66

Lake George. 1920
Gelatin-silver print. 9½ x 7⅝" (24.3 x 19.4 cm).
The Museum of Modern Art, New York.
The Alfred Stieglitz Collection, gift of
Georgia O'Keeffe
Frontispiece

Waldo Frank. 1920
Palladium print. 9⅞ x 7¹⁵⁄₁₆" (25.1 x 20.2 cm).
The Art Institute of Chicago. The Alfred
Stieglitz Collection
Page 63

Mrs. Hedwig Stieglitz. c. 1920
Gelatin-silver print. 4⅝ x 3⅝" (11.8 x 9.2 cm).
National Gallery of Art, Washington, D.C.
Alfred Stieglitz Collection
Page 38

Mrs. Hedwig Stieglitz and Katherine Herzig,
Lake George. Probably 1920
Gelatin-silver print. 2¹¹⁄₁₆ x 3⁹⁄₁₆" (6.9 x 9 cm).
National Gallery of Art, Washington, D.C.
Alfred Stieglitz Collection
Page 47

Lake George. 1920s
Gelatin-silver print. 7⁹⁄₁₆ x 9⁷⁄₁₆" (19.2 x 24 cm).
National Gallery of Art, Washington, D.C.
Alfred Stieglitz Collection
Page 46

Portrait of a Woman, Lake George.
Probably 1920–21
Gelatin-silver print. 4½ x 3⁹⁄₁₆" (11.5 x 9 cm).
National Gallery of Art, Washington, D.C.
Alfred Stieglitz Collection
Page 40

Georgia Engelhard. 1921
Gelatin-silver print. 9⅝ x 7⅝" (24.4 x 19.4 cm).
The Museum of Modern Art, New York.
The Alfred Stieglitz Collection, gift of
Georgia O'Keeffe
Page 61

Georgia O'Keeffe. 1921
Platinum-palladium print. 9⅞ x 7⅞" (25.3 x
19.9 cm). The Metropolitan Museum of Art,
New York. Extended Loan from the Estate of
Georgia O'Keeffe, 1949
Page 53

Lake George. 1921
Palladium print. 9⅞ x 7⅞" (25.1 x 20 cm).
The Art Institute of Chicago. The Alfred
Stieglitz Collection
Page 69

Legs, Elizabeth and Donald. 1921
Palladium print. 9⅝ x 7¹¹⁄₁₆" (24.5 x 19.5 cm).
National Gallery of Art, Washington, D.C.
Alfred Stieglitz Collection
Page 56

Margaret Treadwell. 1921
Gelatin-silver print. 4⁵⁄₁₆ x 3⁷⁄₁₆" (11 x 8.7 cm).
National Gallery of Art, Washington, D.C.
Alfred Stieglitz Collection
Page 55

Margaret Treadwell. 1921
Palladium print. 9½ x 7⅝" (24.3 x 19.3 cm).
National Gallery of Art, Washington, D.C.
Alfred Stieglitz Collection
Page 54

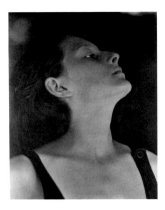

Margaret Treadwell. 1921
Palladium print. 9⅝ x 7⁹⁄₁₆" (24.5 x 19.2 cm).
National Gallery of Art, Washington, D.C.
Alfred Stieglitz Collection

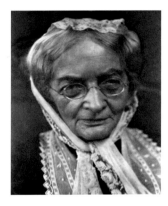

Mrs. Stieffel. 1921
Palladium print. 9⅝ x 7⅝" (24.5 x 19.3 cm).
National Gallery of Art, Washington, D.C.
Alfred Stieglitz Collection

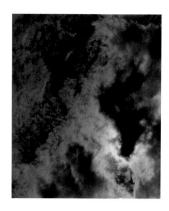

Equivalent E. 1921–38
Gelatin-silver print. 4⅝ x 3⅝" (11.6 x 9.1 cm).
The Museum of Modern Art, New York. Given
anonymously

Apple and Drops of Rain. 1922
Gelatin-silver print, 4⅜ x 3⁷⁄₁₆" (11.1 x 8.8 cm).
National Gallery of Art, Washington, D.C.
Alfred Stieglitz Collection
Page 65

Lake George. 1922
Gelatin-silver print. 4½ x 3⁹⁄₁₆" (11.4 x 9.1 cm).
The Art Institute of Chicago. The Alfred
Stieglitz Collection
Page 60

*Music—A Sequence of Ten Cloud Photographs,
No. I.* 1922
Palladium print. 7⅞ x 9⅞" (20.1 x 25.3 cm).
International Museum of Photography at George
Eastman House, Rochester, New York. Part
purchase and part gift of An American Place
Page 67

*Music—A Sequence of Ten Cloud Photographs,
No. IV.* 1922
Gelatin-silver print. 9½ x 7½" (24 x 19.2 cm).
National Gallery of Art, Washington, D.C.
Alfred Stieglitz Collection
Page 71

*Music—A Sequence of Ten Cloud Photographs,
No. VIII.* 1922
Gelatin-silver print. 9⅜ x 7½" (24.1 x 19 cm).
National Gallery of Art, Washington, D.C.
Alfred Stieglitz Collection
Page 70

Portrait. 1922
Palladium print. 9¹⁵⁄₁₆ x 7¹⁵⁄₁₆" (25.3 x 20.2 cm).
The Art Institute of Chicago. The Alfred
Stieglitz Collection
Page 64

Carriage and Barn, Lake George.
c. 1922
Gelatin-silver print. 7½ x 9⁷⁄₁₆" (19.1 x 24 cm).
National Gallery of Art, Washington, D.C.
Alfred Stieglitz Collection
Page 37

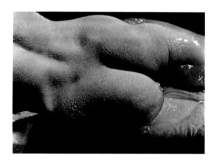

Lake George. 1922–23
Gelatin-silver print. 3⅝ x 4¹¹⁄₁₆" (9.2 x 11.9 cm).
The Art Institute of Chicago. The Alfred
Stieglitz Collection

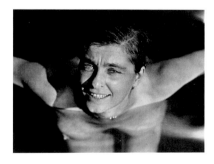

Untitled (Rebecca Strand). 1922–23
Gelatin-silver print. 3⁹⁄₁₆ x 4⅝" (9.1 x 11.8 cm).
The Art Institute of Chicago. The Alfred
Stieglitz Collection

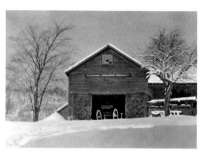

Barn, Lake George. 1923
Gelatin-silver print. 3⅜ x 4½" (8.6 x 11.5 cm).
National Gallery of Art, Washington, D.C.
Alfred Stieglitz Collection

Barn in Winter, Lake George. 1923
Gelatin-silver print. 7½ x 9½" (19.1 x 24.2 cm).
National Gallery of Art, Washington, D.C.
Alfred Stieglitz Collection
Page 80

Barns, Lake George. 1923
Gelatin-silver print. 7½ x 9½" (19.2 x 24.2 cm).
The Metropolitan Museum of Art, New York.
Gift of David A. Schulte, 1928
Page 82

First Snow and the Little House. 1923
Gelatin-silver print. 7½ x 9⅜" (19 x 24 cm).
National Gallery of Art, Washington, D.C.
Alfred Stieglitz Collection
Page 83

George and Yvonne Boursault, Lake George. 1923
Gelatin-silver print. 4½ x 3⁷⁄₁₆" (11.5 x 8.8 cm).
The J. Paul Getty Museum. The Alfred
Stieglitz Collection
Page 58

Hay Wagon, Lake George. 1923
Palladium print. 7⅝ x 9½" (19.3 x 24.2 cm).
National Gallery of Art, Washington, D.C.
Alfred Stieglitz Collection
Page 41

Katherine. 1923
Gelatin-silver print. 4¾ x 3⁵⁄₁₆" (12.1 x 8.4 cm).
National Gallery of Art, Washington, D.C.
Alfred Stieglitz Collection

Lake George. 1923
Gelatin-silver print. 9⁹⁄₁₆ x 7⁹⁄₁₆" (24.3 x 19.2 cm).
The Art Institute of Chicago. The Alfred
Stieglitz Collection
Page 81

Lake George in Winter. 1923
Gelatin-silver print. 7½ x 9⁷⁄₁₆" (19.1 x 23.9 cm).
National Gallery of Art, Washington, D.C.
Alfred Stieglitz Collection
Page 79

Lake George in Winter. 1923
Gelatin-silver print. 7⁷⁄₁₆ x 9⁷⁄₁₆" (18.9 x 23.9 cm).
National Gallery of Art, Washington, D.C.
Alfred Stieglitz Collection
Page 78

Rebecca Salsbury Strand. 1923
Gelatin-silver print. 4½ x 3⁹⁄₁₆" (11.4 x 9 cm).
National Gallery of Art, Washington, D.C.
Alfred Stieglitz Collection
Page 50

Rebecca Salsbury Strand. 1923
Gelatin-silver print. 3½ x 4¹¹⁄₁₆" (8.9 x 11.9 cm).
National Gallery of Art, Washington, D.C.
Alfred Stieglitz Collection
Page 52

Rebecca Strand. 1923
Gelatin-silver print. 3⁵⁄₈ x 4¹¹⁄₁₆" (9.3 x 11.9 cm).
International Museum of Photography at George
Eastman House, Rochester, New York. Part
purchase and part gift of An American Place
Page 51

Songs of the Sky. 1923
Gelatin-silver print. 4¹¹⁄₁₆ x 3⁵⁄₈" (11.9 x 9.2 cm).
National Gallery of Art, Washington, D.C.
Alfred Stieglitz Collection
Page 77

Spiritual America. 1923
Gelatin-silver print. 9¾ x 7¾" (24.8 x 19.7 cm).
The Art Institute of Chicago. The Alfred
Stieglitz Collection
Page 68

*An Equivalent in a Series of Two Equivalents,
Print X.* 1923–38
Gelatin-silver print. 4¹¹⁄₁₆ x 3¹¹⁄₁₆" (12 x 9.2 cm).
The Museum of Modern Art, New York. Given
anonymously
Page 73

*An Equivalent in a Series of Two Equivalents,
Print Y.* 1923–38
Gelatin-silver print. 4⁵⁄₈ x 3⁵⁄₈" (11.7 x 9.2 cm).
The Museum of Modern Art, New York. Given
anonymously
Page 72

*Georgia O'Keeffe: A Portrait—with Donald
Davidson.* 1924
Gelatin-silver print. 3⁹⁄₁₆ x 4⁵⁄₈" (9.1 x 11.7 cm).
National Gallery of Art, Washington, D.C.
Alfred Stieglitz Collection
Page 57

Georgia O'Keeffe: A Portrait—with Ida O'Keeffe.
1924
Gelatin-silver print. 3¹¹⁄₁₆ x 4¹¹⁄₁₆" (9.3 x 11.9 cm).
National Gallery of Art, Washington, D.C.
Alfred Stieglitz Collection

Equivalent. 1925
Gelatin-silver print. 4⁵⁄₈ x 3⁹⁄₁₆" (11.7 x 9.1 cm).
National Gallery of Art, Washington, D.C.
Alfred Stieglitz Collection
Page 75

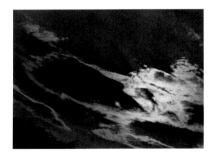

Equivalent. 1925
Gelatin-silver print. 3½ x 4⁵⁄₈" (9 x 11.7 cm).
National Gallery of Art, Washington, D.C.
Alfred Stieglitz Collection

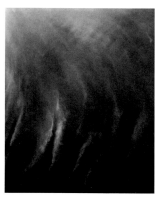

Equivalent. 1925
Gelatin-silver print. 4¹¹⁄₁₆ x 3⅝" (12 x 9.2 cm).
The Museum of Modern Art, New York.
The Alfred Stieglitz Collection, gift of
Georgia O'Keeffe

Sue Davidson. 1925
Gelatin-silver print. 4½ x 3½" (11.4 x 8.9 cm).
National Gallery of Art, Washington, D.C.
Alfred Stieglitz Collection

Equivalent. 1925–35
Gelatin-silver print. 4⁷⁄₁₆ x 3⅝" (11.2 x 9.2 cm).
National Gallery of Art, Washington, D.C.
Alfred Stieglitz Collection
Page 76

Moon. c. 1926
Gelatin-silver print. 7½ x 9½" (19.2 x 24.1 cm).
National Gallery of Art, Washington, D.C.
Alfred Stieglitz Collection
Page 91

Lake George. 1927 (?)
Gelatin-silver print. 7½ x 9½" (19 x 24.1 cm).
The Museum of Modern Art, New York.
The Alfred Stieglitz Collection, gift of
Georgia O'Keeffe

Equivalent. 1929
Gelatin-silver print. 7⅜ x 9⁷⁄₁₆" (18.8 x 24.0 cm).
The J. Paul Getty Museum. The Alfred
Stieglitz Collection
Page 84

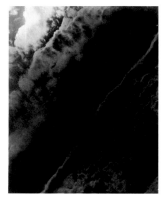

Equivalent, Set C Print 3. 1929
Gelatin-silver print. 4¾ x 3¾" (12 x 9.5 cm). The
Museum of Modern Art, New York. The Alfred
Stieglitz Collection, gift of Georgia O'Keeffe

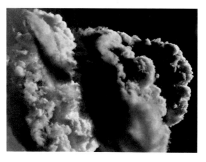

Equivalent, Set X Print 3. 1930
Gelatin-silver print. 3⅜ x 4¼" (8.5 x 10.8 cm).
National Gallery of Art, Washington, D.C.
Alfred Stieglitz Collection

Equivalent. 1931
Gelatin-silver print. 4⅝ x 3⁹⁄₁₆" (11.8 x 9.1 cm).
National Gallery of Art, Washington, D.C.
Alfred Stieglitz Collection
Page 74

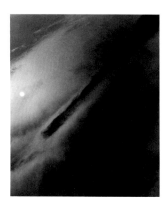

Equivalent. 1931
Gelatin-silver print. 4⅝ x 3⅝" (11.7 x 9.2 cm).
The Museum of Modern Art, New York.
The Alfred Stieglitz Collection, gift of
Georgia O'Keeffe

Georgia O'Keeffe. 1931
Gelatin-silver print. 7⁷⁄₁₆ x 9⅜" (19 x 23.9 cm).
The Metropolitan Museum of Art, New York.
Extended Loan from the Estate of Georgia
O'Keeffe, 1949
Page 96

Lake George. 1931
Gelatin-silver print. 7½ x 9⁷⁄₁₆" (19.1 x 24 cm).
National Gallery of Art, Washington, D.C.
Alfred Stieglitz Collection
Page 86

Lake George. 1931
Gelatin-silver print. 7⅜ x 9⅜" (18.8 x 24 cm).
National Gallery of Art, Washington, D.C.
Alfred Stieglitz Collection
Page 87

Richard. 1931
Gelatin-silver print. 4⅝ x 3⅝" (11.7 x 9.2 cm).
National Gallery of Art, Washington, D.C.
Alfred Stieglitz Collection
Page 94

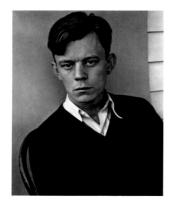

Cary Ross. 1932
Gelatin-silver print. 9⅜ x 7⅜" (23.4 x 18.5 cm).
National Gallery of Art, Washington, D.C.
Alfred Stieglitz Collection

*Jerome Mellquist and Paul Rosenfeld, Lake
George.* 1932
Gelatin-silver print. 7⁷⁄₁₆ x 9⁵⁄₁₆" (18.9 x 23.6 cm).
National Gallery of Art, Washington, D.C.
Alfred Stieglitz Collection
Page 59

Lake George. 1932
Gelatin-silver print. 9½ x 7½" (24.1 x 19 cm).
The Museum of Modern Art, New York.
The Alfred Stieglitz Collection, gift of
Georgia O'Keeffe
Page 88

Lake George. 1932
Gelatin-silver print. 9⅜ x 7⅜" (23.9 x 18.7 cm).
The Museum of Modern Art, New York.
The Alfred Stieglitz Collection, gift of
Georgia O'Keeffe
Page 89

Lake George. 1932
Gelatin-silver print. 4½ x 3⅝" (11.5 x 9.3 cm).
The Museum of Modern Art, New York.
The Alfred Stieglitz Collection, gift of
Georgia O'Keeffe
Page 8

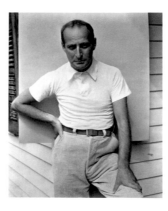

Louis Kalonyme. 1932
Gelatin-silver print. 8¾ x 7¹⁄₁₆" (22.3 x 17.9 cm).
National Gallery of Art, Washington, D.C.
Alfred Stieglitz Collection

Untitled (Poplars, Lake George). 1932
Gelatin-silver print. 9⁵⁄₁₆ x 7⁷⁄₁₆" (23.7 x 18.9 cm).
San Francisco Museum of Modern Art. Purchase,
Alfred Stieglitz Collection

Georgia O'Keeffe. 1933
Gelatin-silver print. 3⅝ x 4⁹⁄₁₆" (9.2 x 11.6 cm).
The Art Institute of Chicago. The Alfred
Stieglitz Collection
Page 62

Georgia O'Keeffe. 1933
Gelatin-silver print. 9½ x 7½" (24.1 x 19 cm).
The Museum of Modern Art, New York.
The Alfred Stieglitz Collection, gift of
Georgia O'Keeffe

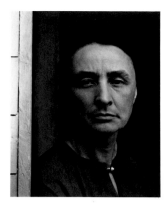

Georgia O'Keeffe: A Portrait. 1933
Gelatin-silver print. 9⅜ x 7⅜" (23.9 x 18.7 cm).
The J. Paul Getty Museum. The Alfred
Stieglitz Collection

Georgia O'Keeffe: A Portrait. 1933
Gelatin-silver print. 9½ x 7½" (24 x 19 cm).
The J. Paul Getty Museum. The Alfred
Stieglitz Collection
Page 90

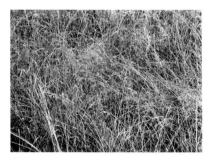

Lake George. 1933
Gelatin-silver print. 5⅝ x 7¼" (14.3 x 18.4 cm).
The Art Institute of Chicago. The Alfred
Stieglitz Collection

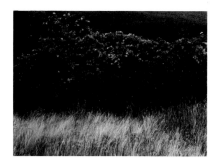

Lake George. 1933–34
Gelatin-silver print. 7¼ x 9¼" (18.4 x 23.4 cm).
Dorothy Norman Collection, courtesy Howard
Greenberg Gallery, New York

Lake George. 1933–34
Gelatin-silver print. 7¼ x 9⁵⁄₁₆" (18.4 x 23.7 cm).
The Museum of Modern Art, New York.
Given anonymously
Page 85

Barn and Car. 1934
Gelatin-silver print. 3¹¹⁄₁₆ x 4⅝" (9.3 x 11.8 cm).
National Gallery of Art, Washington, D.C.
Alfred Stieglitz Collection

Door to Kitchen. 1934
Gelatin-silver print. 9½ x 7⅜" (24.1 x 18.8 cm).
National Gallery of Art, Washington, D.C.
Alfred Stieglitz Collection
Page 95

House and Grape Leaves. 1934
Gelatin-silver print. 9½ x 7⅝" (24.3 x 19.5 cm).
National Gallery of Art, Washington, D.C.
Alfred Stieglitz Collection
Page 97

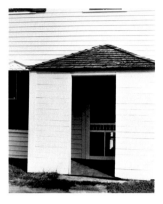

Lake George. 1934
Gelatin-silver print. 9⁵⁄₁₆ x 7⅛" (23.7 x 18.1 cm).
The Art Institute of Chicago. The Alfred
Stieglitz Collection

Little House, Lake George. Probably 1934
Gelatin-silver print. 9⅜ x 7⅜" (24 x 18.8 cm).
National Gallery of Art, Washington, D.C.
Alfred Stieglitz Collection
Page 93

Car 2F 77-77. 1935
Gelatin-silver print. 7⅝ x 9½" (19.4 x 24.1 cm).
The Museum of Modern Art, New York. Given
anonymously
Page 98

Margaret Prosser. 1936
Gelatin-silver print. 8⁵⁄₁₆ x 7⅜" (21.1 x 18.8 cm).
San Francisco Museum of Modern Art.
Foto Forum Purchase, gift of Rena Bransten
Page 92

ACKNOWLEDGMENTS

I have wondered who Stieglitz was and what he meant for half a century, and it is not easy for me to know where my present ideas have come from. Clearly, my understanding of Stieglitz was marked first and perhaps most deeply by the testimony of the great generation of American photography that came after him: Edward Weston, Paul Strand, Ansel Adams, Berenice Abbott, Walker Evans, and Ralph Steiner all expressed their views of Stieglitz and his work. These authors contradicted each other and themselves, and were consistent only in the passion with which their opinions of their great predecessor were expressed. The subject of these views was unmistakably a force of consequence: probably a saint, possibly a false prophet, conceivably both. Later, more measured and objective voices—Doris Bry, William Homer, Sue Davidson Lowe, Sarah Greenough, Benita Eisler—have given us an historic Stieglitz, and I am grateful to them for this, and thankful that they have not altogether exorcised the mythic one.

In 1983 I asked Georgia O'Keeffe to permit the National Gallery of Art to lend Stieglitz photographs to an exhibition on his work at Lake George (and to another exhibition on Stieglitz's late work in Manhattan.) This request was in effect a request for permission to do the exhibition, since it could not have been done without the incomparable richness of the National Gallery's Stieglitz collection. Miss O'Keeffe agreed to my request, and also proposed that pictures that were not available from the National Gallery might be borrowed from other museum collections to which she had made restricted gifts after Stieglitz's death. Her decision has been honored and expedited by Juan Hamilton, then O'Keeffe's Assistant and now a Director of the Georgia O'Keeffe Foundation. Without Mr. Hamilton's generous sympathy, and that of Elizabeth Glassman, President of the Foundation, this project might have been mired for years in arid legalistic quibbling.

Among my friends and colleagues in the museum world, I owe my deepest gratitude to Sarah Greenough of the National Gallery of Art, who not only lent with extraordinary generosity from that institution's definitive Stieglitz collection, but who also shared her deep knowledge of Stieglitz, and who did me the great favor of reading and criticizing this book's introductory essay.

Where I have expressed views that diverge from hers, it is with great trepidation.

I am also deeply in debt to David Travis of The Art Institute of Chicago for the very generous loans from that museum's Stieglitz collection—one that is unsurpassed in quality—and also for permission to cite his unpublished Stieglitz lecture "Beyond Virtuosity." I am grateful as well to Weston Naef of The J. Paul Getty Museum, who has lent without reservation from the superb collection formed at the Getty (I would not have thought it possible) within the past decade; to Sandra S. Phillips of the San Francisco Museum of Modern Art, for the loans from the collection of that institution, and for her valuable counsel; and to Maria Morris Hambourg of The Metropolitan Museum of Art, for lending the rare *Barns, Lake George*, 1923, as well as two prints from the Metropolitan's exceptional holding from the cumulative portrait of Georgia O'Keeffe. Special thanks are due James Enyeart, Director of George Eastman House, who at the eleventh hour lent rare prints of pictures that had been expected from another source.

I am grateful to Dorothy Norman for the loan of a print from her private collection and also for the privilege of hearing her own recollections and understandings of Stieglitz's last years as an active photographer.

Doris Bry has shared her virtually encyclopedic knowledge of Stieglitz's work without reservation, and has made it a pleasure to learn. Peter Bunnell has also contributed selflessly from his years of research and thought on Stieglitz.

I am grateful to Joel Snyder for sharing with me the content of his 1980 conversation with Beaumont Newhall, and for his cogent criticism of this book's introductory essay.

For their valuable help with research problems, I want to thank Virginia Zabriskie and Peter MacGill, and also Carlotta Owens and Julia Thompson, of the National Gallery of Art; Kristin Nagel of The Art Institute of Chicago; Doug Nickel of the San Francisco Museum of Modern Art; Catherine Bindman of The Metropolitan Museum of Art; Deborah Roan, Assistant to Dorothy Norman; Joan Dooley, Julian Cox, and Laura Muir of the J. Paul Getty Museum; and Ben Trask of The Mariners' Museum.

Thomas W. Collins, Beaumont and Nancy Newhall Fellow at The Museum of Modern Art, has served as my assistant on this project, and as such has done most of the hard and disciplined work that such an enterprise entails, leaving the fun for me. I thank him for his research, for the organization of many processes, for liaison within and outside the Museum, and for asking the right questions at the right times.

The installation of the exhibition has been supervised by Jerome Neuner.

Those responsible for the quality of this book are Emily Waters, its designer, Amanda W. Freymann, its production supervisor, and Harriet Schoenholz Bee, the editor of its text, whom I thank for her tolerance and flexibility, and for the unnecessary commas that she has allowed to stand. The beauty of the plates is primarily due to Robert J. Hennessey, who has made the reproduction negatives with his customary skill.

Peter Galassi, Chief Curator in the Museum's Department of Photography, has been steadfast in his support of the project, meaning that he has persuaded a thousand people that it should be done and that they should help. His criticism has, as always, been of inestimable help.

Finally, I would like to thank Walter Y. Elisha and Springs Industries, Inc., for supporting this project, and for demonstrating once again their commitment to the art of photography and its public.

John Szarkowski